IMAGES
of America

HUNTINGTON BEACH
CALIFORNIA

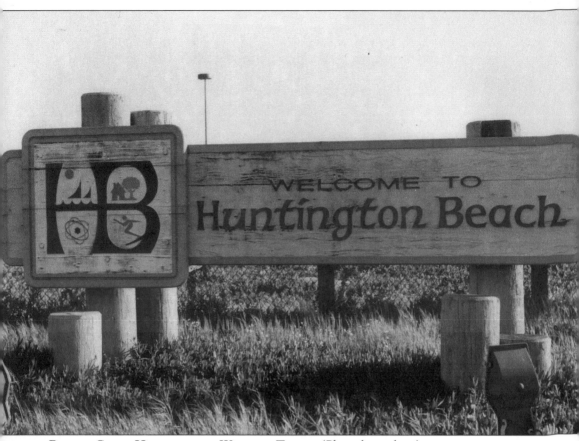

PACIFIC COAST HIGHWAY AND WARNER, TODAY. (Photo by author.)

IMAGES
of America

HUNTINGTON BEACH

CALIFORNIA

Chris Epting

ARCADIA

Published by Arcadia Publishing,
an imprint of Tempus Publishing, Inc.
3047 N. Lincoln Ave., Suite 410
Chicago, IL 60657

Printed in Great Britain.

Library of Congress Catalog Card Number: 2001090195

For all general information contact Arcadia Publishing at:
Telephone 843-853-2070
Fax 843-853-0044
E-Mail sales@arcadiapublishing.com

For customer service and orders:
Toll-Free 1-888-313-2665

Visit us on the internet at http://www.arcadiapublishing.com

I would like to dedicate this book to Alicia Wentworth. Alicia first came to Huntington Beach in 1947. In 1961 she became Deputy City Clerk and in 1973 was appointed City Clerk. After retiring in 1988, the City Council appointed her City Historian, which is an understatement. My son Charlie and I have spent some valuable mornings and afternoons with Alicia, looking through photos and asking questions, all the while listening to vivid recollections of what this city used to be like. Thank you, Alicia. Huntington Beach would not be the same without you. (Photos compliments of Alicia Wentworth, City Historian, except where indicated.)

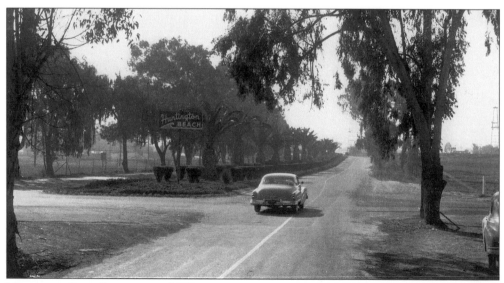

MAIN AND CLAY STREETS, C. 1950.

CONTENTS

ACKNOWLEDGMENTS

Working on this book has been a wonderful experience for me, one that brought me closer to this special city and to those around me.

Thanks to my wife Jean, for her overall patience and the shuttling back and forth to Bill's Camera for whatever it was I needed that particular day. As usual, I couldn't have it without her. To my daughter Claire, for patiently watching me shoot photos off the pier before we kicked our shoes off and played in the ocean. To my son Charlie, for exploring with me, helping line up the "Then and Now" shots, taking some of the pictures, and just for being such an incredible, all-round helper. How a seven-year old child can possess such a keen, innate interest in history is beyond my comprehension. Though just maybe, (as we uttered to each other more than once during this adventure), "Like father, like son." To historian Alicia Wentworth, for her knowledge, kindness, and good company. To City Clerk Connie Brockway, for the gracious use of her office while Charlie and I pored over old photos in her office. To Keith Ulrich at Arcadia Publishing, for his guidance, tips, and advice. To the ladies at the International Surfing Museum, for letting me shoot some photos there and for running such a cool place. To surfing legend Corky Carroll, for hanging with me for a few so I could get the details right. To the guys at Bill's Camera for turning stuff around so fast. To my mom and sisters just because.

And to each one of you holding this book right now.

Thank you so much for your interest.

Images of America
Huntington Beach

INTRODUCTION

Though we've only lived here for little over a couple of years, it's hard for me to imagine my family and I not spending the rest of our lives in Huntington Beach. The weather is near perfect; never too hot or too cold. All year, gentle breezes carry the scent of the ocean throughout the city and with it, the innocence and promise of summer. It's situated close to all of the area's major cities from Los Angeles to San Diego to Palm Springs. Points of interest including Disneyland, Knotts Berry Farm, and my personal favorite, Anaheim Stadium, are all no more than a 30-minute drive.

The snow-covered San Gabriel Mountains provide a picturesque backdrop in winter, when daytime temperatures can still linger in the 60s and 70s. On clear days, even though it's 26 miles out at sea, Catalina Island seems close enough to touch. While it's been developed more than I'm sure some of the locals would prefer, Huntington Beach still retains a good amount of small town, beach city charm. The beaches are roomy and far-reaching, yet within a mile are some of Orange County's most beautiful parks and recreational areas. There are lots of great restaurants and hangouts. And if you like to surf, well, this town is called "Surf City" for a reason.

It's a unique place with an interesting history, which is why I started looking for some sort of historical picture book when I moved here. I love books like that. Lots of pictures. Good captions. Books you can wander with. But one didn't exist. So I thought I'd propose the idea to a publisher who creates books like that. And so here we are. Now, had I found a book like this in the first place, I'd want it to have brief history of Huntington Beach. So here goes.

The birth of this city occurred more than 100 years ago. Originally a 30,000-acre Spanish land grant, the Stearns Rancho company ran cattle and horses and raised barley on what is now Huntington Beach. Around 1890, the city was called Shell Beach, becoming Pacific City in 1901 when P.A. Stanton formed a local syndicate and bought 40 acres along the beach. In 1904, the town name was changed to Huntington Beach in honor of H.E. Huntington, who sponsored the extension of the Pacific Electric Railway to the seaside village. Incorporated in 1909, Huntington Beach remained a quiet seaside town until the famous oil boom in the 1920s. Almost every major oil company began producing oil from the rich field below. Wells sprang up literally overnight and in less than a month, the town grew from 1,500 to 5,000 people, and many folks got rich instantly. In fact, many east coasters who were given lots of Huntington Beach land years before as part of an encyclopedia sales promotion now found themselves scrambling to find the deeds that would make many of them rich. In addition to the oil

production, Huntington Beach also became known for its agricultural strengths. Produce like lima beans, sugar beets, chili peppers, tomatoes, celery, and more grew easily in the fertile soil. From 1957 to 1960, Huntington Beach exploded in size to 25 square miles. In 1956, construction started on the huge Edison generating plant along Pacific Coast Highway and in 1963, the Douglas Aircraft Systems Center opened. This brought major industry to the city, and nearly 8,000 people were employed at the plant. During the 1960's, Huntington Beach earned the nickname "Surf City" when the popular duo Jan and Dean released the song of the same name. All across the nation, the allure and carefree spirit of the beach lifestyle took root. Today, Huntington Beach still earns its nickname—it's home to the International Surfing Museum, the U.S. Open Surfing Championships, and some of the best year-round recreational surfing in the country. The famous Huntington Beach Pier, first built in 1904, rebuilt in 1914, 1940, 1988 and finally to its current length in 1992, remains the focal point of the city's Main Street district—a symbol of rejuvenated dreams, hope and determination.

A few details about the book. Whether you live in Huntington Beach or you're just visiting, I've tried to create a book that's fun to wander with. I tried to find some of the best photos available, though I'm sure there are hundreds more hiding in boxes someplace. Although the city's nickname is "Surf City," I did not do an extensive chapter on surfing. There are many great surfing books available, and the surf culture took shape relatively late in the city's historical development. My purpose and intention was to simply gather classic images as a souvenir of the city's earlier history and origin, because to my knowledge, it has not yet been done. While I wish more detailed notations had been recorded on many of the old photos, I found some good source books, most notably the *Historical Data Collection* prepared by Alicia Wentworth, *From Barley Fields to Oil Town* (Claudine Burnett, 1995), and *Huntington Beach, The Gem of the South Coast* (Diann Marsh, 1999). However, there may still be some inaccuracies, which I regret.

Lastly, the day I went out to photograph the final pier shot for the "Then and Now" chapter, my son Charlie and I had Chinese food on the beach. Afterwards, I got the following fortune: "The past is theirs; the future is ours." (Lucky #1, 6, 8, 28, 29, 40)

This struck me as an ironic message to receive the day I was to wrap up shooting photos for this book, which for me, had become a rich, historic journey. Philosophically, I agree with the thought. However, I'd like to believe that this book does sort of let the past become yours, at least for a little while.

Enjoy.

One

GENERAL HISTORY
BUILDINGS, PEOPLE, AND
LANDMARKS

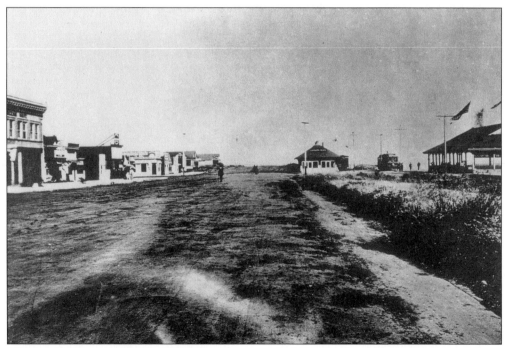

OCEAN AVENUE, ABOUT 1909. Before it was called Pacific Coast Highway, this road was called Ocean Avenue. This view is looking east toward the intersection of Main Street. The "Red Car" is seen at the Huntington Beach train depot on the right, with the Pier Pavilion (later to become the Pier Restaurant) on the far right.

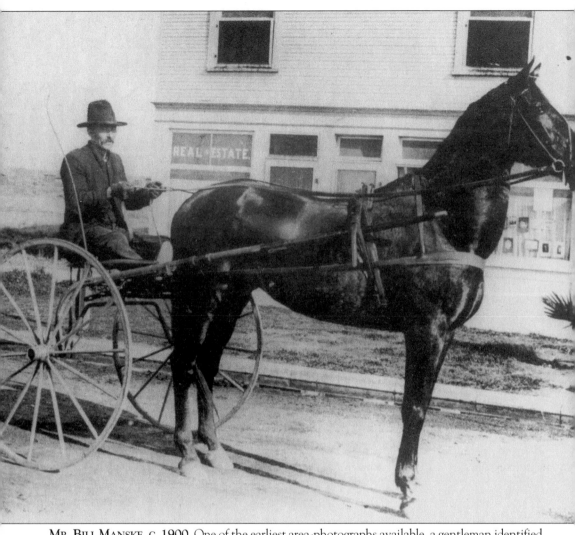

Mr. Bill Manske, c. 1900. One of the earliest area-photographs available, a gentleman identified as "Mr. Bill Manske" poses with his horse and buggy on Main Street near the ocean, *c.*1900.

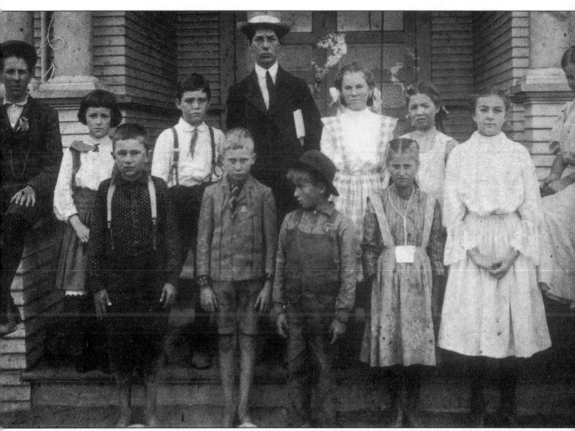

STUDENTS AT THE FIRST GRAMMAR SCHOOL, ABOUT 1908. As these students pose on the steps of the fist grammar school in Huntington Beach, notice that the boys in the front row are barefoot and the girls are not. Supposedly, it was not considered proper behavior for young girls to show their bare feet in public.

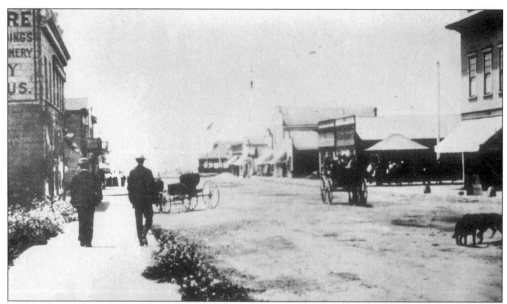

MAIN AND WALNUT, 1910. Some horse and buggies and even a couple of dogs are seen wandering Main Street toward the beach in the quiet, pre-oil era of Huntington Beach. Nothing is left of this today, save for the scent of the salty sea air.

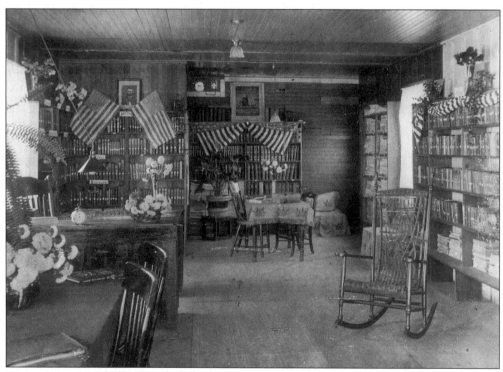

PUBLIC LIBRARY, 1907. This is the main room of the first library built in Huntington Beach. Several years later, the Carnegie Foundation would help build the city a bigger and better public library.

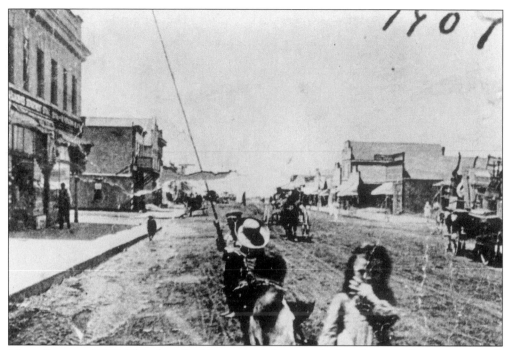

MAIN STREET, 1907. This shot (looking toward the ocean), though not a clear image, struck me as interesting. Maybe it's the little girl near the center of the frame, who looks as if she might be mugging a bit to the photographer. How strange a contraption a camera must have seemed in 1907 to someone so little.

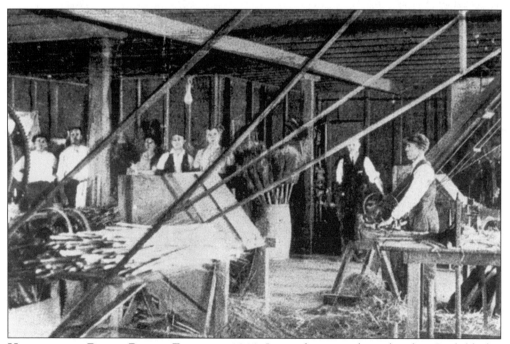

HUNTINGTON BEACH BROOM FACTORY, 1910. Located next to the railroad at Garfield, this company operated from 1906 until it burned down in the mid-1960s.

13

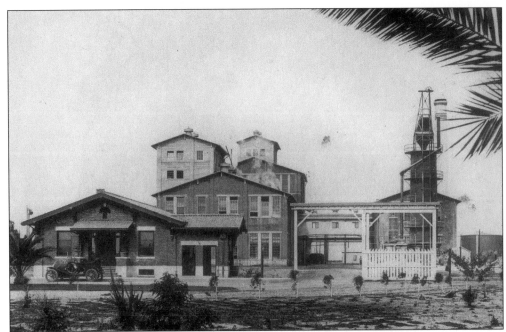

HOLLY SUGAR FACTORY AT MAIN AND GARFIELD, 1911. The Holly Sugar Factory was opened and began processing sugar beets in 1910. By the late 1920s, it would be converted to function as an oil refinery.

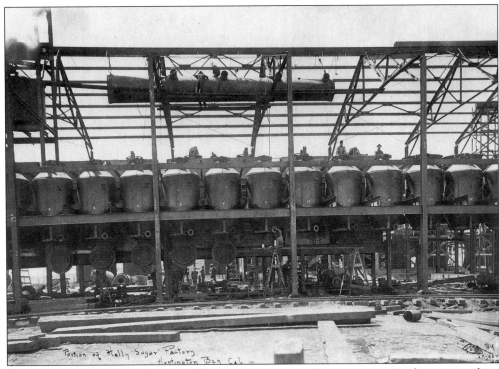

HOLLY SUGAR FACTORY, C. 1920. These vats represented just one step in the sugar making process once the beets were crushed.

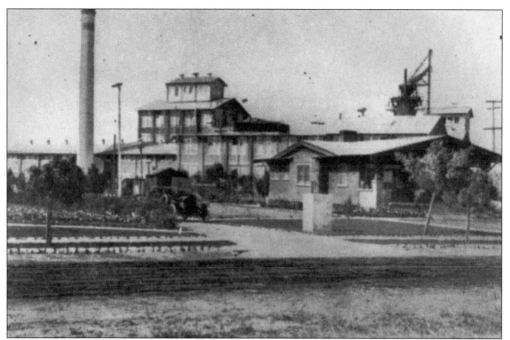

HOLLY SUGAR FACTORY, SUMMER, 1911. As the picture caption reads, at one time this was the second largest sugar factory in the U.S.

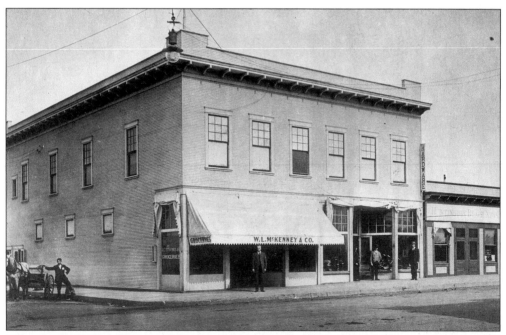

"UNOFFICIAL" CITY HALL AT MAIN AND WALNUT, C. 1910. W.L. McKenney may have sold groceries out of this old building, but the structure was perhaps best known for being Huntington Beach's "unofficial City Hall". This was the gathering place for those wishing to discuss municipal affairs and many who decided to run for city council did so because of discussions held here.

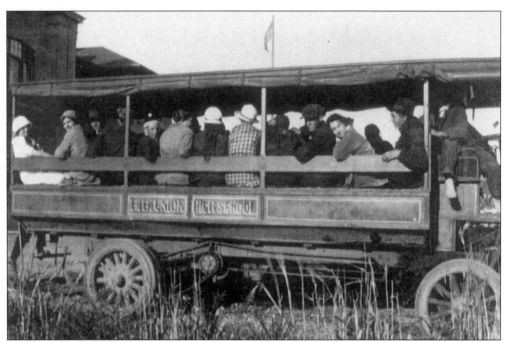

FIRST SCHOOL BUS, 1910. These teenagers are being transported to Huntington Beach Union High School on the town's first real "school bus."

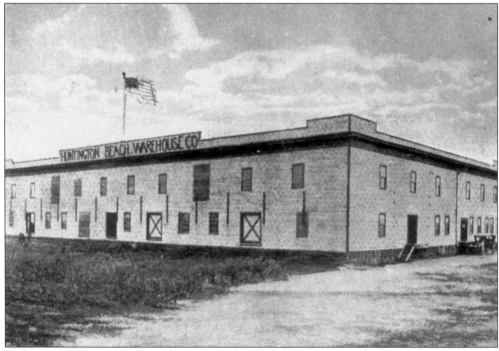

LARGE BEAN WAREHOUSE, C. 1910. Just after the turn of the century, Huntington Beach provided substantial agricultural supplies to much of the area, resulting in warehouses like this one, primarily located on the outskirts of town.

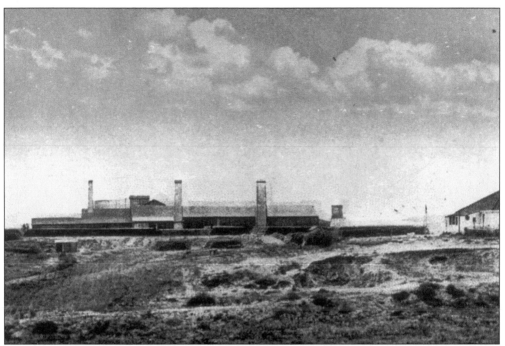

LA BOLSA TILE COMPANY LOCATED AT GOTHARD AND ELLIS, C. 1910. At one time, this became the largest clay tile factory west of Chicago, and provided year-round employment for many Huntington Beach residents.

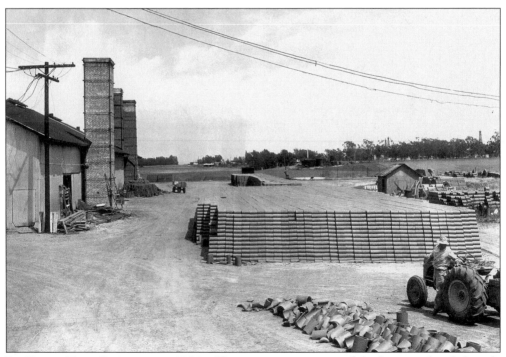

LA BOLSA TILE COMPANY, C. 1930S. Here you can see some of the huge stacks of clay tile produced at the plant. Off in the distance on the right, oil wells can be seen.

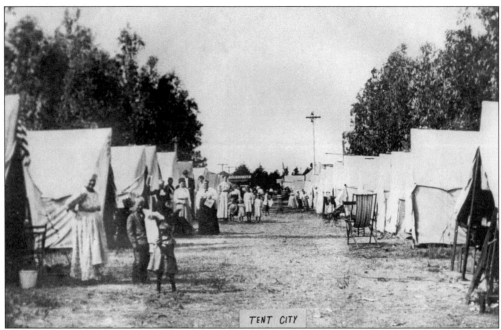

TENT CITY, C. 1907. The Women's Christian Temperance Union of Huntington Beach ran a rest cottage for women visitors at the Southern California Methodist Association Tent City campsite during the summers of 1905–1920. As many as 15,000 people gathered to hear major speakers and participate in Bible study.

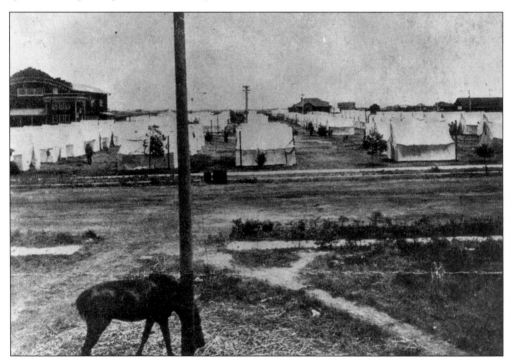

TENT CITY, C. 1910. In the left of this photo, the Methodist Tabernacle Auditorium is visible. It cost $1,000 to build and could hold up to 3,000 people.

18

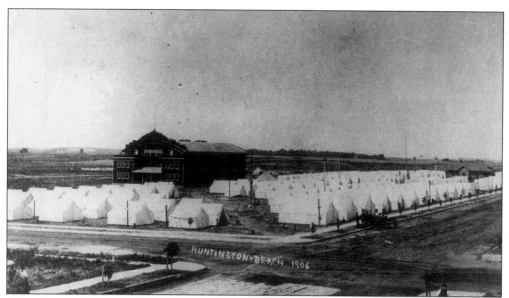

TENT CITY, 1906. This view from Twelfth Street gives you an idea of how organized this area was. The camp sat in what is now a residential area bordered by Orange and Acacia Avenues and Eleventh and Thirteenth Streets.

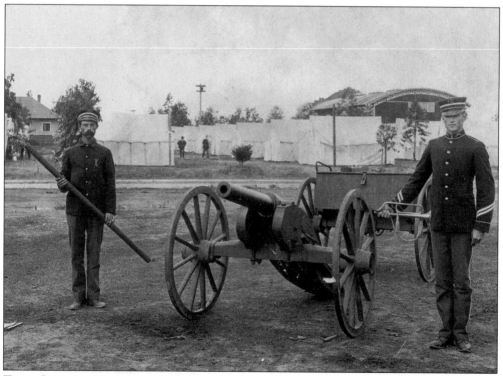

TENT CITY, C. 1918. Two soldiers at the encampment prepare to fire a cannon during a ceremony.

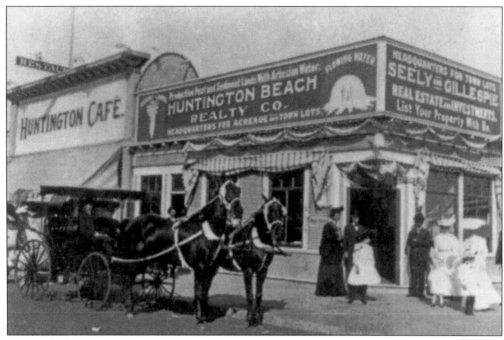

MAIN STREET, 1906. A horse and carriage waits for passengers outside the Huntington Beach Realty Company. Note the ornate hats on the two women at far right.

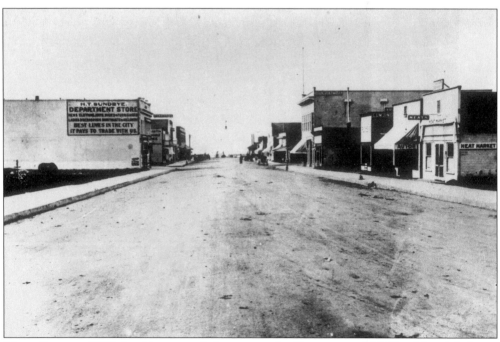

MAIN STREET, 1906. Looking toward the ocean, the Dameron and Hallicy Meat Market is visible on the right; the Sundbye Department store on the left boasts, "It pays to trade with us."

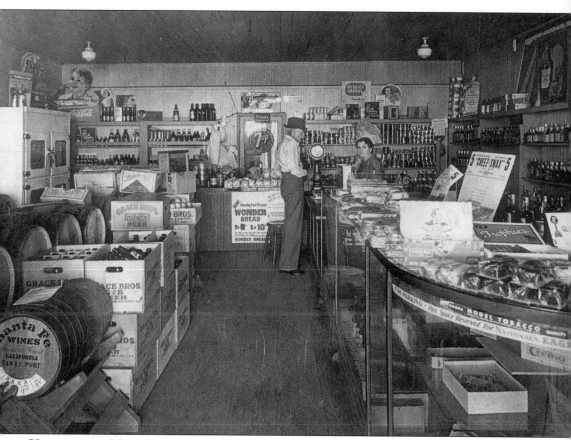

Unidentified Main Street Liquor Store, c. 1930. A few name brands are visible, most notable Coca-Cola, 7-UP, and Wonder Bread.

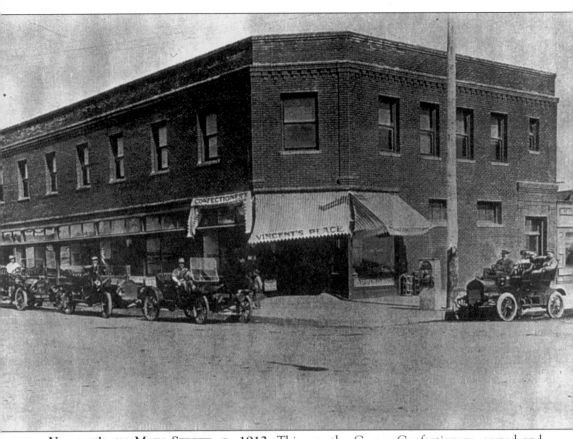

VINCENT'S ON MAIN STREET, C. 1912. This was the Corner Confectionery, owned and operated by Ervin L. Vincent, the town marshall.

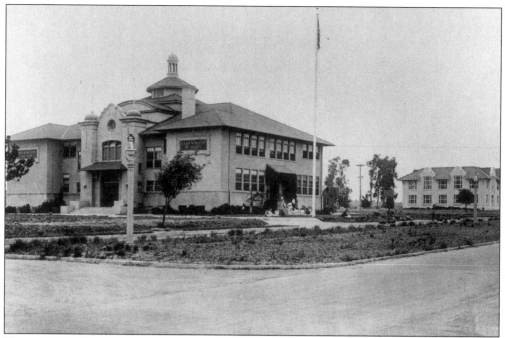

HUNTINGTON BEACH UNION HIGH SCHOOL, 1909. In 1908, the cornerstone for the new high school was laid and students moved in the next year. The building stood at the corner of North Main Street and Union Avenue.

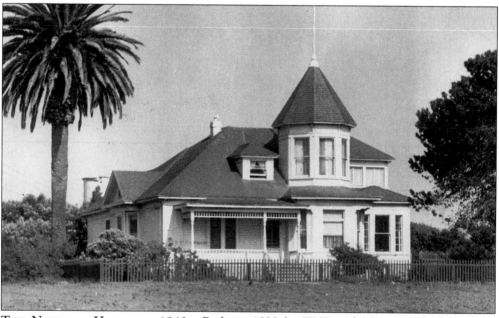

THE NEWLAND HOUSE, C. 1940S. Built in 1898 by W.T. and Mary Newland near the intersection of Beach Boulevard and Adams Avenue, this beautiful two-story farmhouse has been lovingly restored and is now listed on the National Register of Historic Places. The Newlands, one of the most notable families in the area, lived here for 54 years. Today, an excellent tour is offered by the Huntington Beach Historical Society.

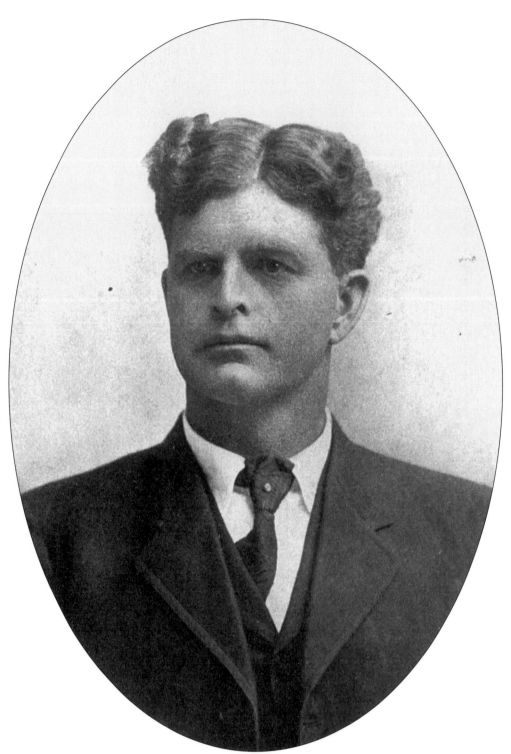

ED MANNING, 1909. This is the first mayor of Huntington Beach at age 37. Historian Alicia Wentworth was actually related to Ed—he was her husband's grandfather.

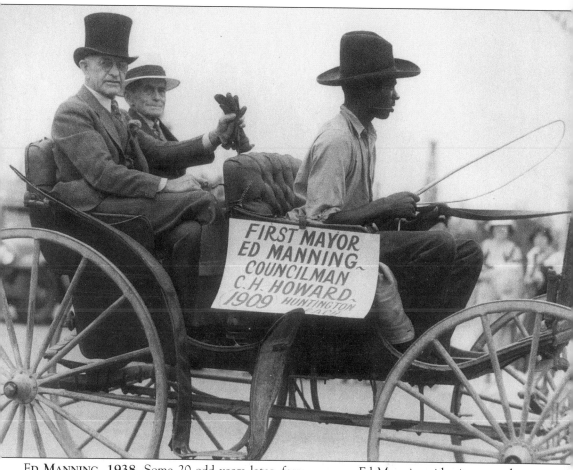

ED MANNING, 1938. Some 20-odd years later, former mayor Ed Manning rides in a parade commemorating the incorporation of the city. Councilman C.H. Howard rides next to him.

The sign in the image reads:

FIRST MAYOR
ED MANNING~
COUNCILMAN
C.H. HOWARD~
1909 HUNTINGTON
BEACH

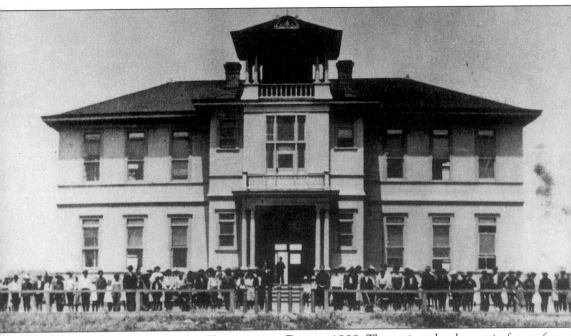

FIRST GRAMMAR SCHOOL IN HUNTINGTON BEACH, 1909. The entire school poses in front of the new building, which had just opened.

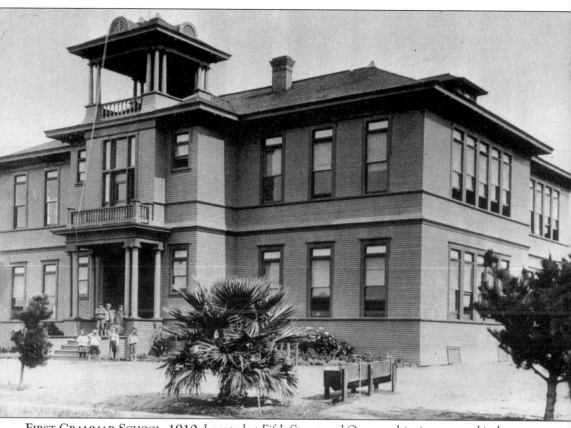

FIRST GRAMMAR SCHOOL, 1910. Located at Fifth Street and Orange, this site was used in later years for the construction of the new city hall.

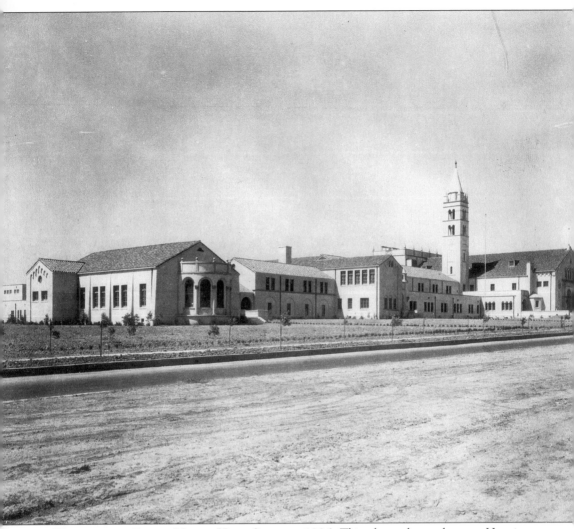

HUNTINGTON BEACH UNION HIGH SCHOOL, 1926. This photo shows the new Huntington Beach High School just after completion in 1926. Note the oil derricks at the far right of the picture. They were located in the fields north of the school, which was in the area of the original oil strikes.

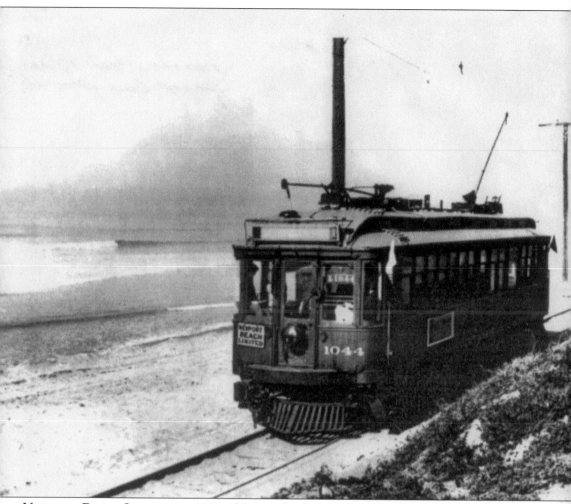

NEWPORT BEACH LIMITED, C. 1920S. Here is the Commodore, Pacific Electric car coming into Newport Beach from Huntington Beach. Note how close to the ocean the cars ran.

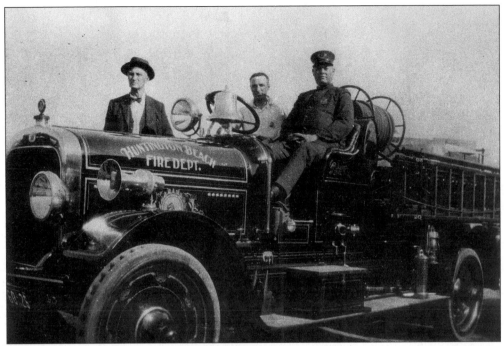

HUNTINGTON BEACH FIRE DEPARTMENT, 1930.

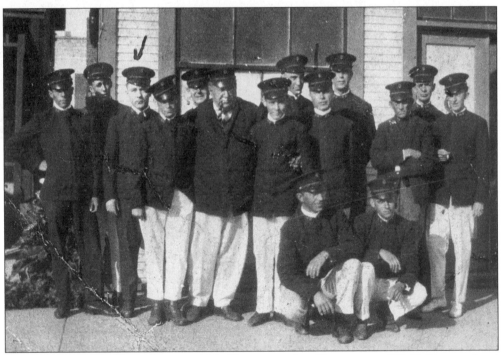

FIRST HUNTINGTON CITY BAND, 1920. The arrow identifies a young Bill Galliene, a local legend who worked as secretary-manager of the Chamber of Commerce for 30 years, and organized many city events including the Christmas and 4th of July parades. However, one of his first loves was always the city band.

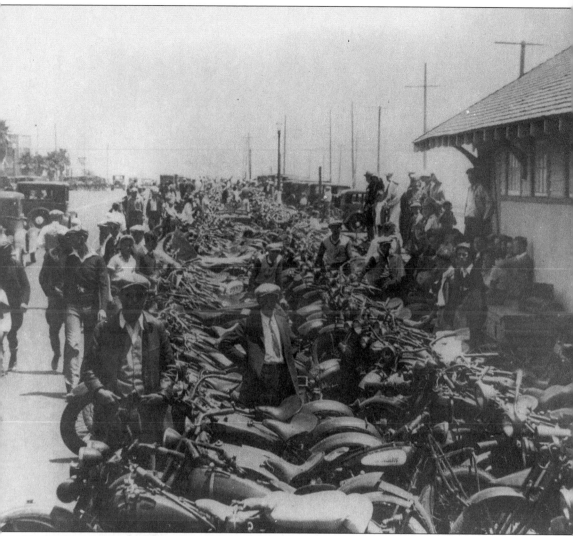

NEXT TO THE PACIFIC ELECTRIC RAILWAY DEPOT, 1928. Up to 2,000 bikers roared into the city each year for the annual motorcycle dealer's picnic.

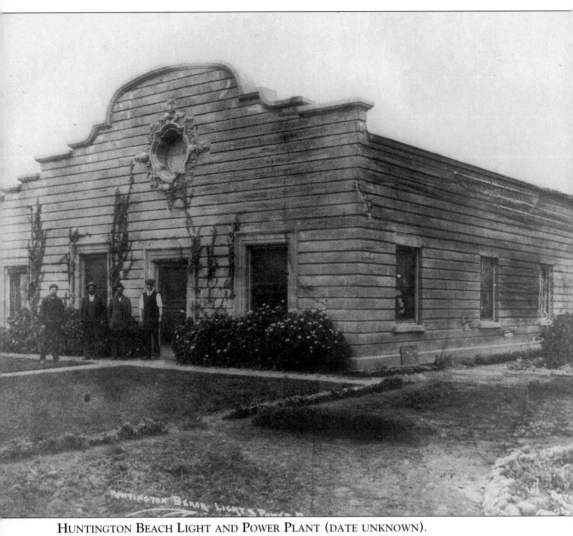

Huntington Beach Light and Power Plant (date unknown).

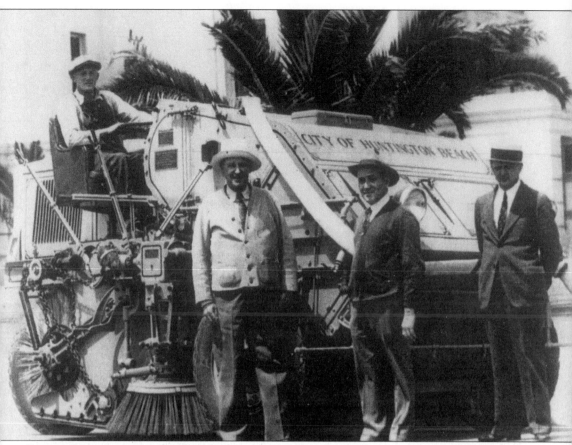

STREET SWEEPER, 1935. In May 1935, Huntington Beach purchased a new street sweeper at a cost of $7,007. Pictured in the driver's seat is Fritz Wanka, and standing proudly below him, left to right, are street superintendent Henry Worth, city councilman Anthony Tovatt, and city engineer Harry Overmeyer.

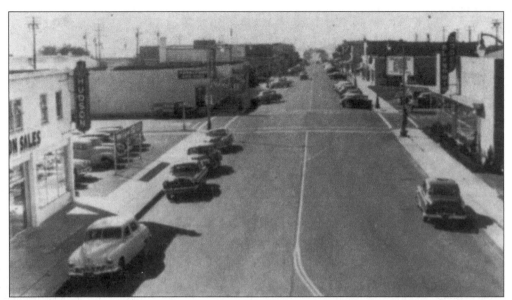

MAIN STREET, 1948. This view, taken near Olive Street, looks towards the Huntington Beach Pier. Walk this area today and you can still identify a few of the remaining buildings from this photo.

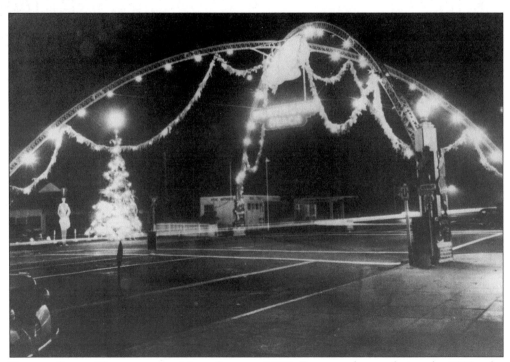

PACIFIC COAST HIGHWAY AND MAIN STREET, 1938. For several years during the 1930s, the intersection of Pacific Coast Highway and Main featured a decorative arch, decorated here for the holidays. It was taken down due to the constant upkeep created by the salty air. The wooden soldier to the left of the Christmas tree sits right by the entrance to the pier.

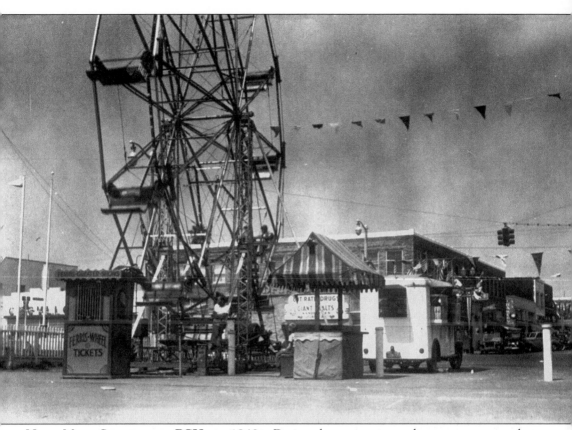

NEAR MAIN STREET AND PCH, C. 1940S. During the summer months, amusements and carnival rides were set up near the pier.

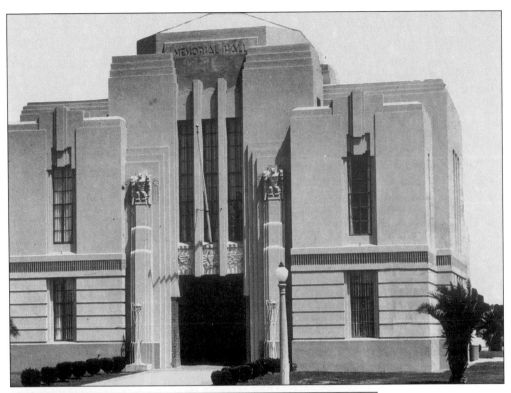

MEMORIAL HALL, C. 1940s.

MEMORIAL HALL, C. 1970s.

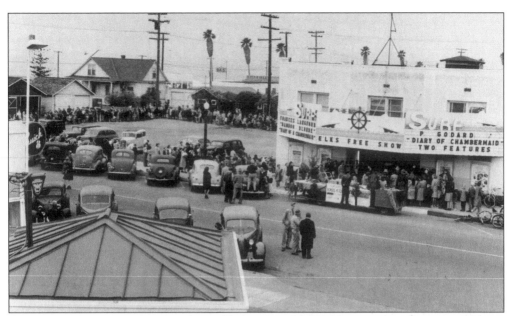

SURF THEATER, C. 1940. Located at Fifth Street and PCH, this was the town movie theater until it was torn down in the 1970s. In this photo, folks are lined up around the block to take part in the Elks Club Christmas Show.

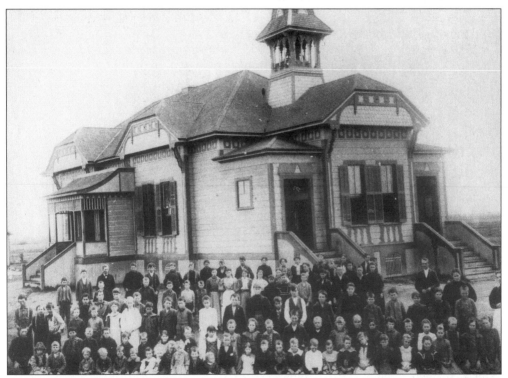

OCEAN VIEW ELEMENTARY SCHOOL, C. 1900. This school was built in 1886 for all the children whose families lived in the many farmlands. It was located near the present site of Beach Boulevard near Warner.

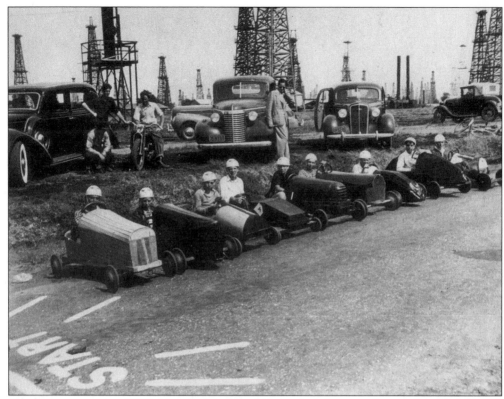

SOAP BOX DERBY, C. 1940. Near PCH, these kids in their homemade soap box derby racers await the starting gun. Note the oil derricks looming nearby.

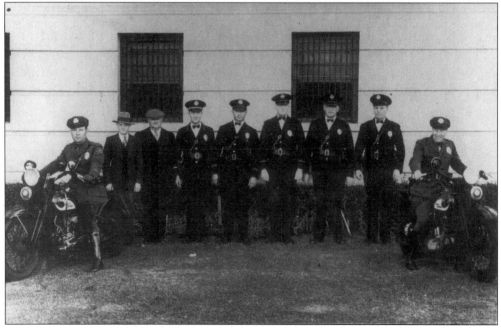

THE HUNTING BEACH POLICE FORCE.

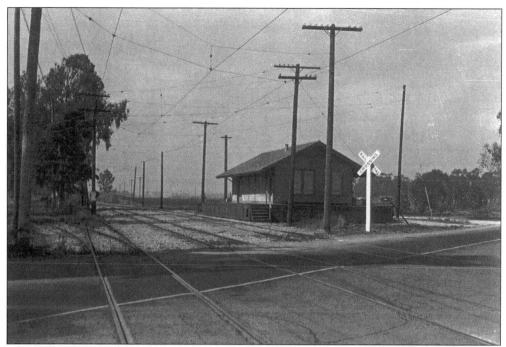

LA BOLSA TRAIN STATION, C. 1939. This station was located near Main and Garfield.

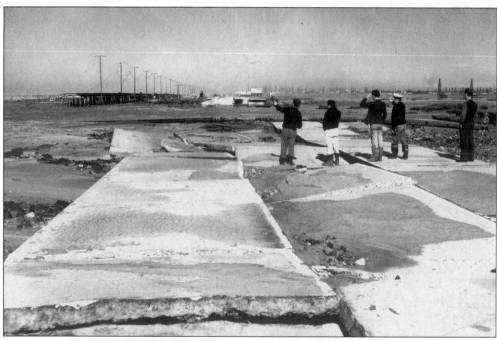

THE GREAT FLOOD OF 1938, NEAR THE SANTA ANA RIVER. In 1938, heavy rainstorms produced extreme floods, the most destructive in Orange County's history. Nineteen lives were lost, two thousand were left homeless, and a thick layer of alkaline silt and debris ruined thousands of acres of farmland. Here, a group near the Santa Ana River assesses some of the damage. They're looking at a washed out PCH.

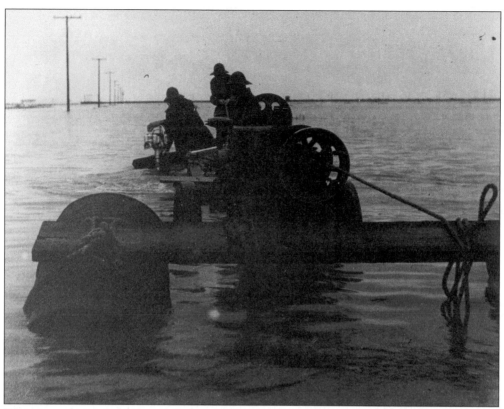

WORKERS DURING THE GREAT FLOOD OF 1938. Men worked around the clock to pump out the flooded river, which is what we are seeing here.

SCOUT CABIN, LAKE PARK, C. 1940. The Boy Scout cabin in Lake Park was built in 1923. It's still there, and just as much a part of Scout activities today as it was then.

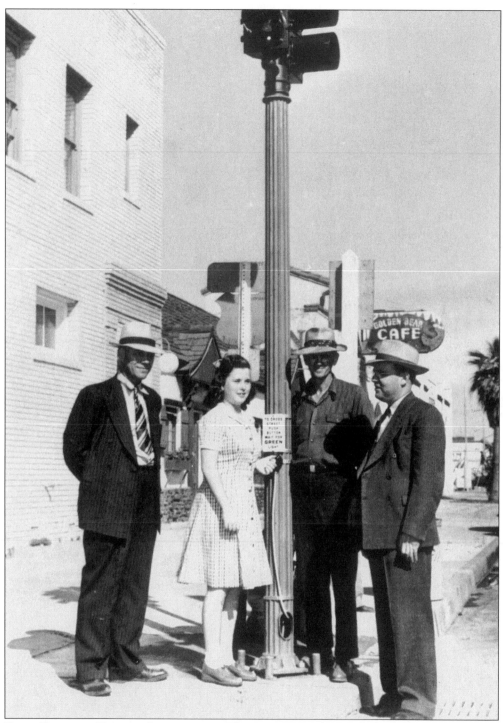

FIRST ELECTRIC TRAFFIC LIGHT, 1942. Huntington Beach installed its first electric traffic light here at the corner of Pacific Coast highway and Main Street. The Golden Bear Cafe can be seen in the background. Pictured: far left is Perry Huddle, Maintenance Yard Supervisor, and on the right is Police Chief Don Blossom. The other two folks are unidentified.

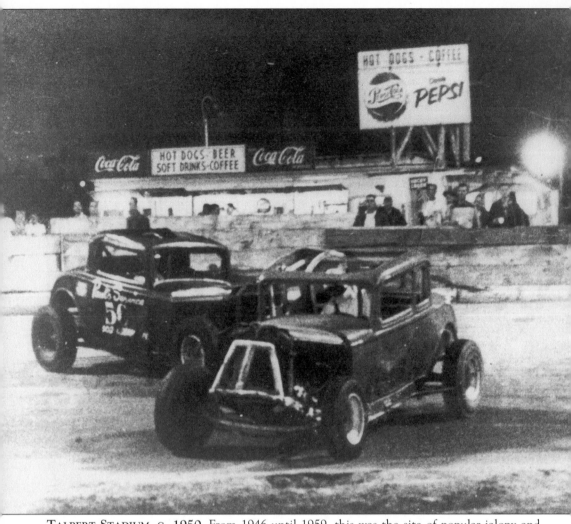

Talbert Stadium, c. 1950. From 1946 until 1959, this was the site of popular jalopy and midget auto races.

SOUVENIR PROGRAM
MIDGET AUTO RACES

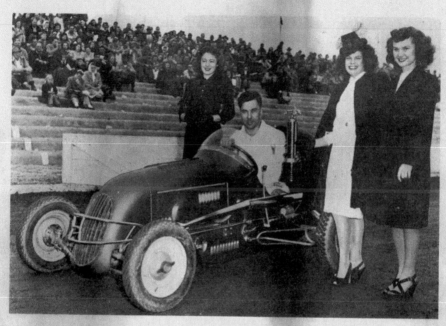

MARTHA LIZARRARAS PRESENTING TROPHY TO BILLY VUKOVICH

Ware & Mathewson Presentation **Bob Ware and Harold Mathewson**

HUNTINGTON BEACH SPEEDWAY

EVERY SUNDAY AFTERNOON PRICE .25

SANCTIONED BY UNITED RACING ASSOCIATION
Sanction No. 4615

—OFFICIALS—

ROY MORRISON, President GEORGE LAWAND—Starter
HERB KOENIG—Pit Manager AMBULANCE—K. & M. Ambulance, Santa Ana
AL. WESSLING—Referee G. LINK—Timer and Scorer
BILL ASAY—Announcer R. TURNER—Steward
SIDNEY SENTER—Track Physician

OFFICIAL TOW CAR—PENCE BROTHERS AUTOMOTIVE SERVICE

PROGRAM, C. 1950s.

43

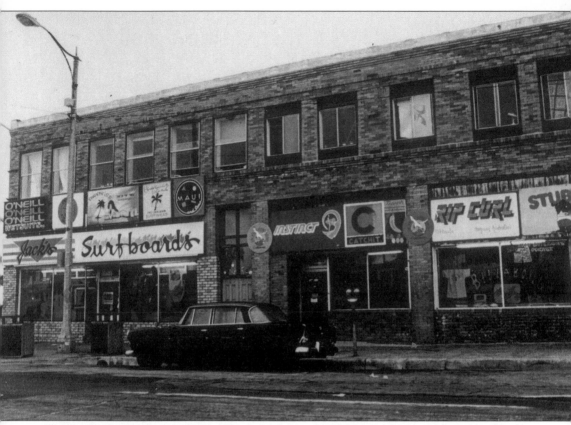

JACK'S SURFBOARDS, C. 1960S. The most famous surf shop in the area, this place has been going strong on this site since 1957, though today Jack's Surfboards is housed in a much bigger, more modern building.

NORTH CITY LIMITS, 1947. Historian Alicia Wentworth shot this photo at the intersection of Main and Clay not long after arriving in town. Note the oil wells off to the right.

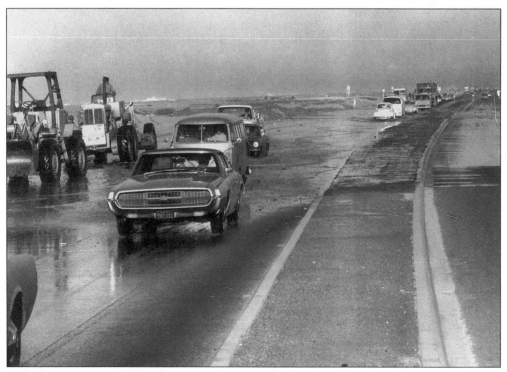

1972 FLOOD ALONG PCH. This particular winter flood required heavy machinery to move the sand from PCH.

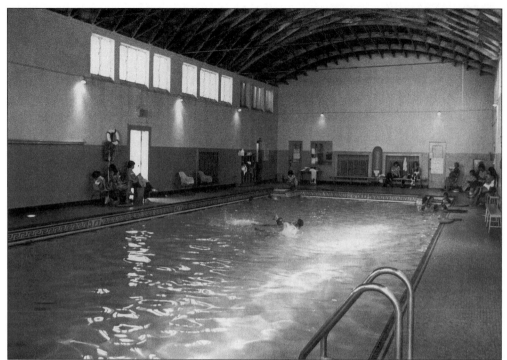

CITY POOL, C. 1970. This is the Huntington Beach Pool on Palm Avenue, originally built for the elementary school. It has since been restored and serves today as the city pool.

MAIN STREET, 1980. (Looking toward the pier.) The building on the far right (217 Main Street) is now called the Longboard Restaurant & Pub and is the oldest remaining building in the city.

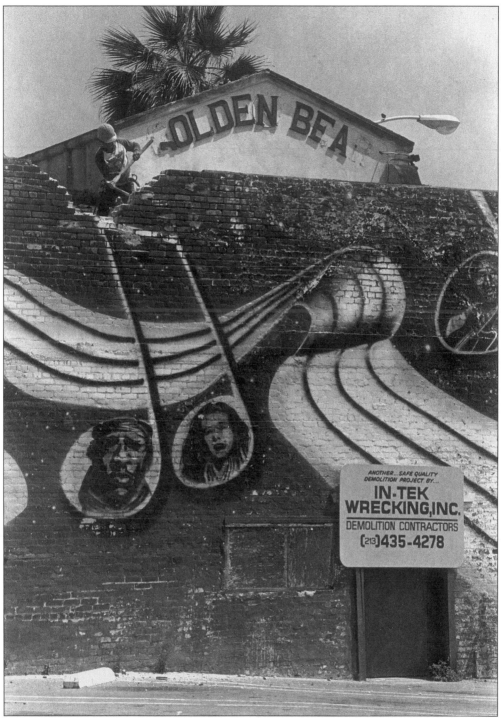

GOLDEN BEAR CAFÉ DEMOLITION, 1986. A landmark nightclub that opened in the 1920s, the Golden Bear played host for years to Hollywood luminaries like Errol Flynn and Clark Gable, then became a premier rock and roll venue featuring everyone from Jimi Hendrix to Linda Ronstadt to Peter Gabriel. Here, the place is in the process of being razed.

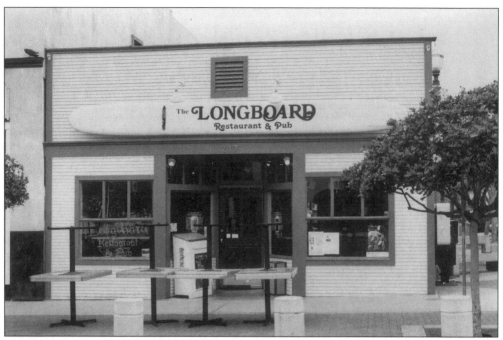

THE LONGBOARD RESTAURANT & PUB, TODAY. This is the oldest remaining building in Huntington Beach. Built in 1904 and located at 217 Main Street, it's been everything from the site of Huntington Beach's first gas pump, to the city's first Japanese grocery store (1912). Today, it's a cozy bar and beach hangout—a great place to grab lunch, a beer, or both. (Photo taken by author.)

SIDE VIEW OF THE LONGBOARD RESTAURANT & PUB, TODAY. This angle gives one a better sense of the building's age. (Photo taken by author.)

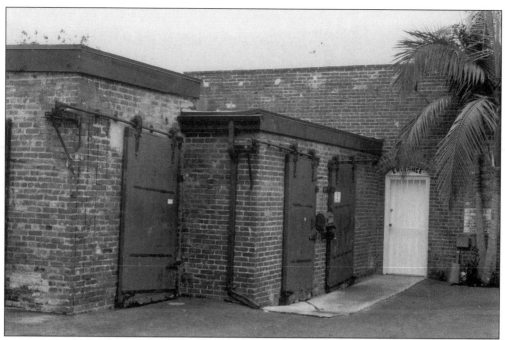

FIRST JAIL CELLS IN HUNTINGTON BEACH, TODAY. Built in the 1914, these imposing brick-and-mortar cells are used for more innocent practices today, acting as storage units. (Photo taken by author.)

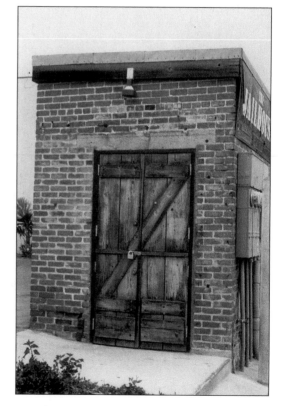

HOLDING TANK, TODAY. This stand-alone cell, adjacent to the row of cells, was where the rowdiest offenders spent the night, essentially in isolation. Located just off Main Street, these cells were strategically placed to handle the flow from the bars along the main drag leading to the pier. (Photo taken by author.)

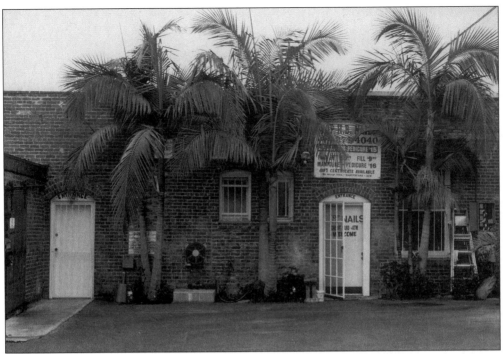

FIRST POLICE HOUSE IN HUNTINGTON BEACH, TODAY. Adjoining the jail cells are the original police house buildings. Today, the building houses a nail salon. (Photo taken by author.)

INTERNATIONAL SURFING MUSEUM, TODAY. Located at 411 Olive, this wonderful museum run by Natalie Kotsch and Ann Beasley is overflowing with artifacts, memorabilia, and souvenirs commemorating the "religion" that earned Huntington Beach the moniker, "Surf City." Make sure you visit. (Photo taken by author.)

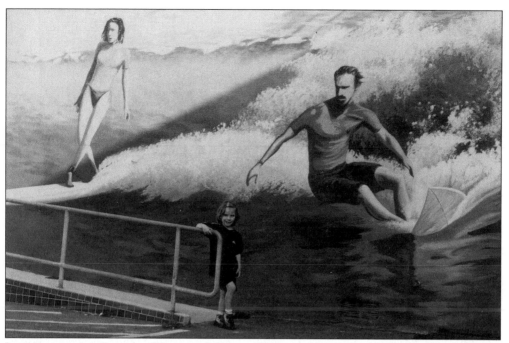

INTERNATIONAL SURFING MUSEUM MURAL, TODAY. Alongside the International Surfing Museum is a mural, which represents Huntington Beach's famous surf culture. It also makes for a prime photo opportunity, as evidenced here by my daughter, Claire. (Photo taken by author.)

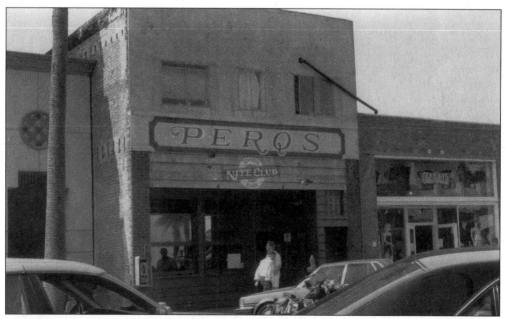

117 MAIN STREET, TODAY. Today in this historic, original brick building you'll find the popular Perq's Nightclub and Sports Bar, which has been open almost 30 years. The building, just one of two truly historic buildings left on Main, was built in 1913. In the 1920s, it was a barber shop and billiard parlor. In the '30s, it was a bar downstairs and a brothel upstairs. (Photo taken by author.)

CENTRAL PARK, TODAY. Central Park is home to the Huntington Beach Central Library, playgrounds, nature center, amphitheater, a charming restaurant, and much more. (Photo taken by author.)

CENTRAL PARK, TODAY. This is a park that offers true solitude within its wide country lanes and rustic, wooded surroundings. Realize that the beach is just over a mile away and you get a sense of how unique this city is. (Photo taken by author.)

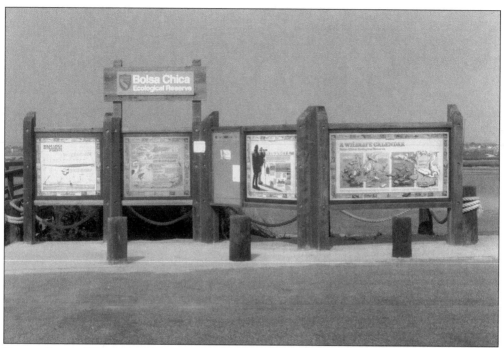

BOLSA CHICA WETLANDS, TODAY. Bordered on one side by Pacific Coast Highway and oil fields and houses on the other, the Wetlands offer a coastal sanctuary for wildlife and migratory birds. (Photo taken by author.)

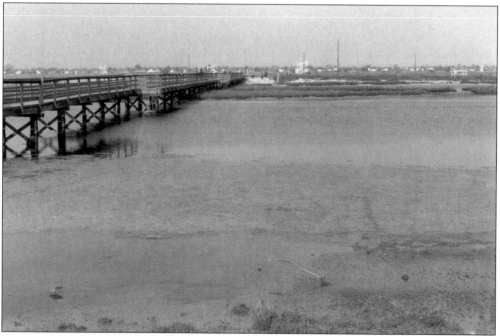

BOLSA CHICA WETLANDS, TODAY. Native American Indians lived on bluffs overlooking the wetlands nearly 8,000 years ago. Today, the 300 acre Reserve has a 1.5 mile loop trail for wildlife viewing, and the area attracts bird watchers from all over the world. (Photo taken by author.)

NEWLAND HOUSE MARKER, TODAY. Located on Beach Boulevard, a mile or so from the Pacific Ocean, a marker directs the visitor to one of Huntington Beach's most classic landmarks. (Photo taken by author.)

NEWLAND HOUSE, TODAY. Still holding her ground amid the mini-malls and restaurants, the Newland House remains a refreshing bit of dignity in a heavily developed stretch of Beach Boulevard. (Photo taken by author.)

Two

THE PIER AND
THE BEACH

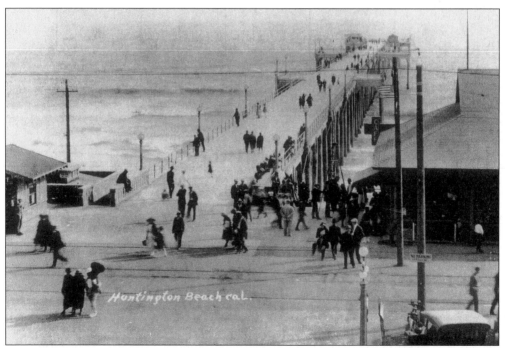

HUNTINGTON BEACH PIER, ABOUT 1904. This was the first wooden pier constructed in Huntington Beach, pictured just after the turn of the century. Little did the folks know, enjoying a stroll on this quaint wooden pier, just how fast their quiet beach side community would soon be growing.

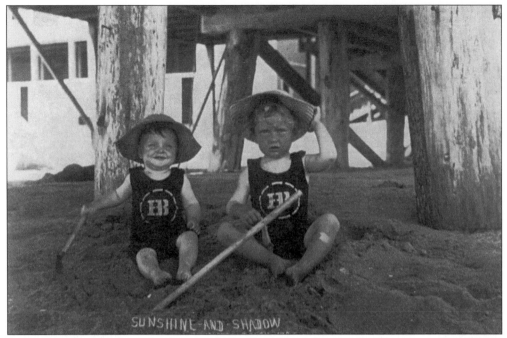

BEACH TODDLERS, 1906. Sunshine and Shadow play under the fist Huntington Beach pier, which was made of wood. Note the "HB" logos on their little swimsuits, which were available for rent by the pier.

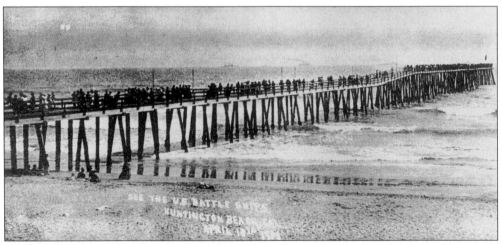

HUNTINGTON BEACH PIER IN 1908. They are hard to make out, but faintly visible on the horizon in this shot is part of the Great White Fleet, ships of the Untied States Navy, sent around the world in 1908–09. President Theodore Roosevelt ordered the worldwide tour as a means of displaying the military might of the United States. People regularly lined up like this all along the West Coast, hoping for a glimpse of the fleet.

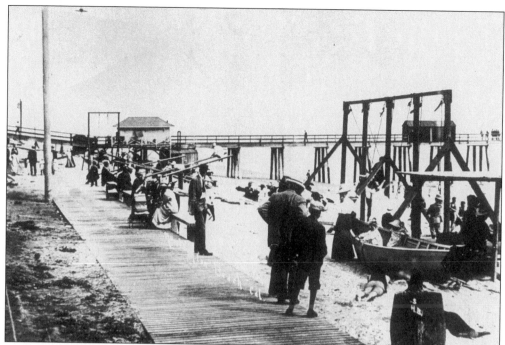

PIER-SIDE, 1910. The boardwalk and children's beach side play area would soon be replaced by the popular Saltwater Plunge.

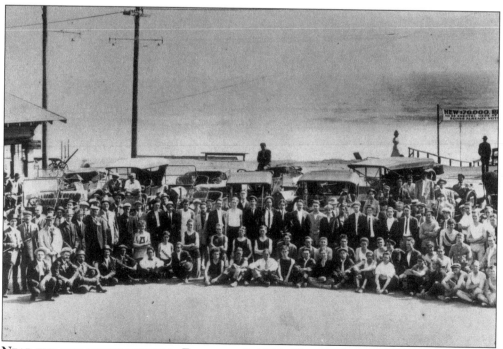

NEAR THE SITE OF THE NEW PIER, FEBRUARY 6, 1912. This event was part of the effort to raise money to build a new pier. The sign off to the right reads, "NEW $70,000 PIER to be erected here at once. Bonds already voted."

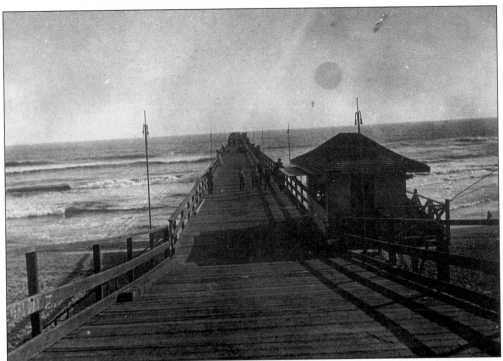

THE ORIGINAL WOODEN PIER, C. 1904. The city's first pier, extending out, as it does today, from Main Street. Winter storms in 1912 would nearly destroy it.

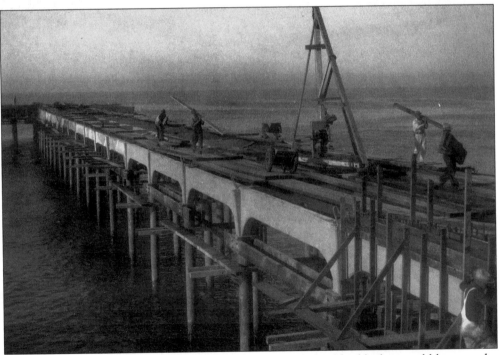

THE NEW PIER BEING BUILT, 1914. For these men who helped build what would become the icon for Huntington Beach, going to work was just another day at the beach.

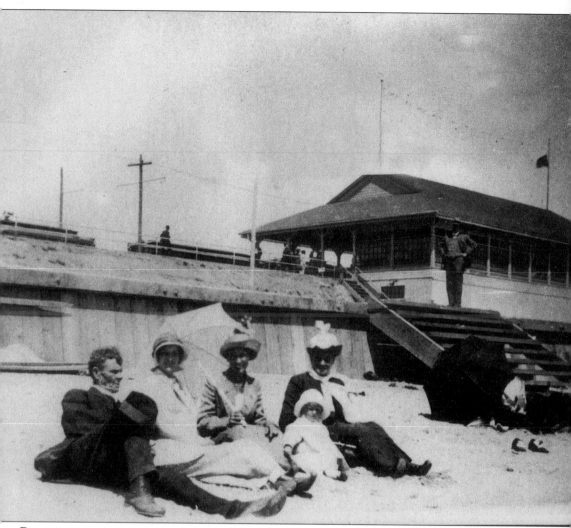

BEACH VISITORS, JUST WEST OF PIER, 1914. The Pier Restaurant sits to the upper right of the well-dressed folks enjoying some sun.

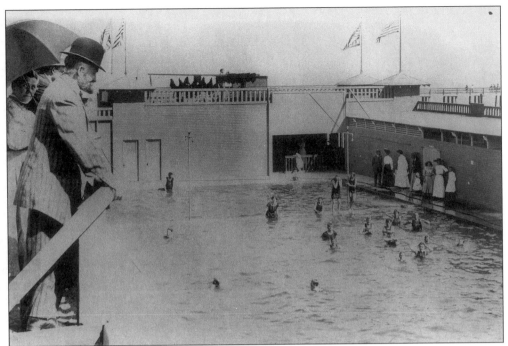

THE SALTWATER PLUNGE, C. 1912. Due to how cold and dangerous the Huntington Beach surf could be, many opted for the heated, soothing waters of the Saltwater Plunge. Located just on the north side of the pier, it was a necessity in this small rural town because many homes lacked indoor plumbing. (The man in the derby enjoying the view is the father of renowned Orange County pioneer, Tom Talbert.)

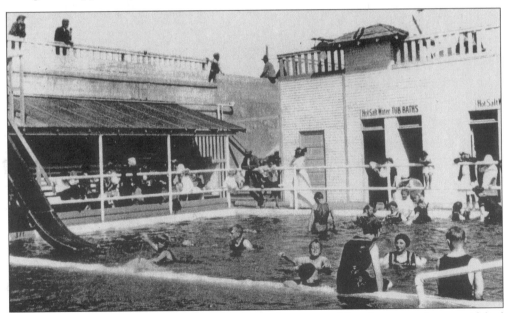

THE SALTWATER PLUNGE, C. 1914. The doors in the center of the photo are where you'd find "Hot Salt Water Tub Baths." The sign on the right states, "Positively no admittance in office in bathing suits."

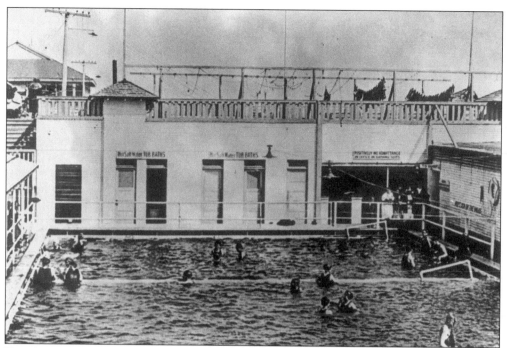

THE SALTWATER PLUNGE, C. 1920S. This view is just after the Plunge has been remodeled. Note the modern-looking slide on the left.

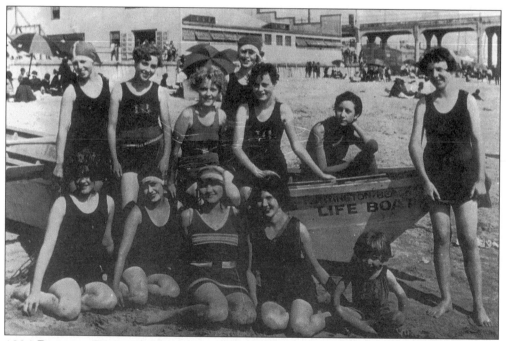

1924 BATHING BEAUTIES. This shot, a daring style of pose in its day, was taken just in front of the Saltwater Plunge (the pier is visible behind the beauties). In fact, the heavy wool suits the women are wearing were rented from the plunge, which were washed and dried each evening after being soaked in a "sheep-dip" disinfectant.

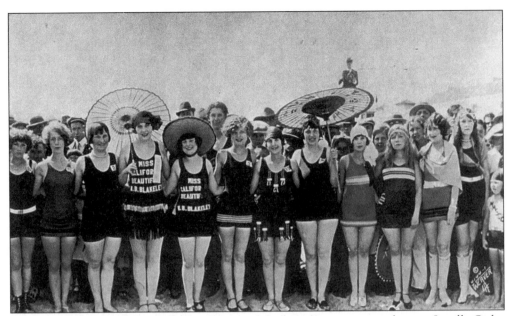

BEACH BEAUTY CONTEST, C. 1930. This beach bathing beauty contest features Lucille Gisler and Agnes Gisler (7th and 8th positions, left to right)

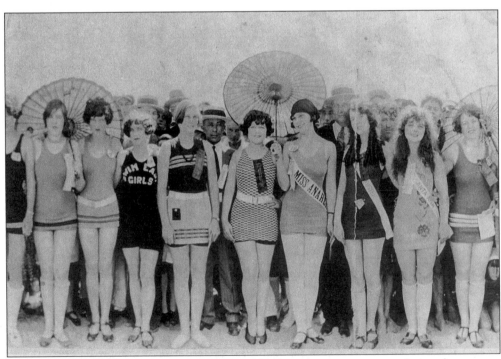

BEACH BEAUTY CONTEST, C. 1920. Contests like this were very common during the summer months.

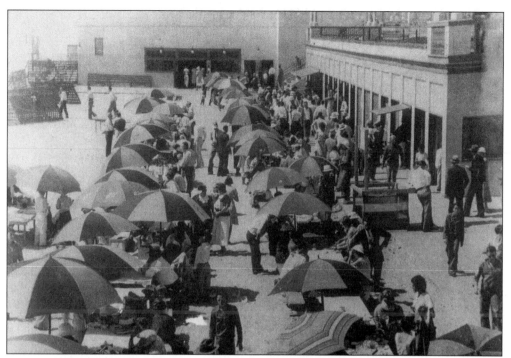

BEACH UMBRELLAS FOR RENT, C. 1930S. Dwight Clapp was a pioneer bench vendor in Huntington Beach who rented up to 200 umbrellas a day, and this photo is evidence of his success. He operated from this site, just north of the pier. (The Saltwater Plunge is at the top of the photo.)

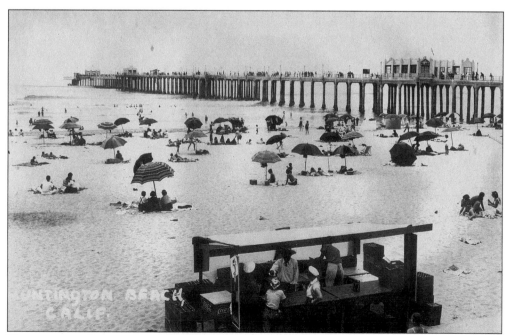

HUNTINGTON BEACH SCENE, 1935. The photo pictures the very first waterfront concession stand to be opened in Huntington Beach.

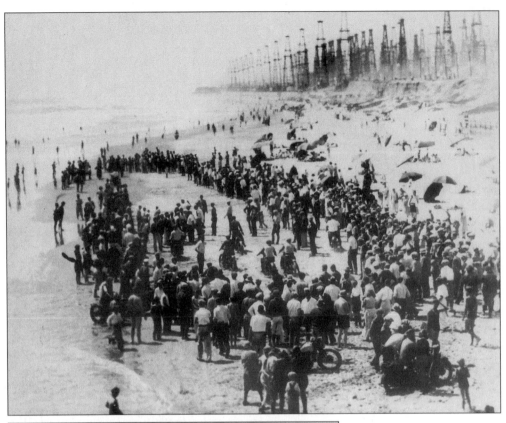

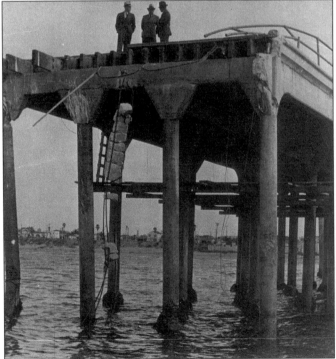

MOTORCYCLE BEACH RACE, MID-1930S. This appears to be a semi-organized event along the coast, though it seems odd that the crowd would enclose both ends of the viewing oval if bikes were seriously racing.

HUNTINGTON BEACH PIER, 1939. The storm of 1938 took a huge toll on the city of Huntington Beach, destroying a 300-foot section of the pier. By August 1940, repairs were completed which brought the pier to its present length of 1,822 feet.

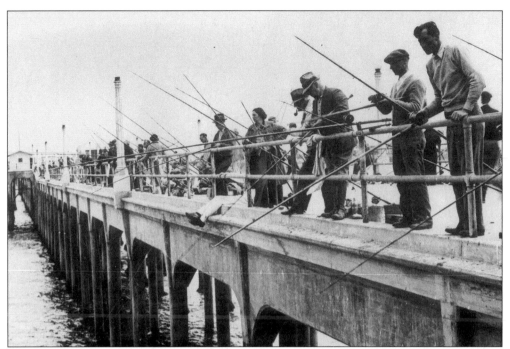

FISHING OFF THE PIER, 1938. To this day, fishing remains a popular pier activity on the Huntington Beach Pier. Halibut and bass are the most common fish you can expect to catch today (and it never gets this crowded.)

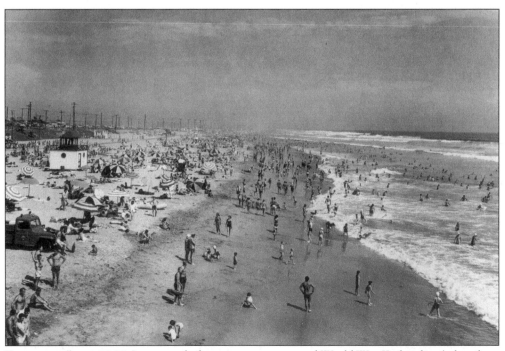

FOURTH OF JULY, 1940. Just a year before our country entered World War II, this shot (taken from the pier) illustrates just how popular Huntington Beach was becoming with Southern Californians.

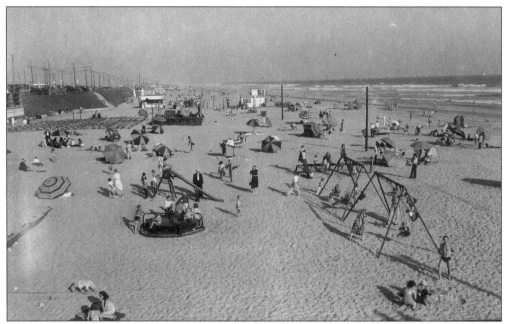

BEACH SCENE, 1940. The children's play area as seen from the pier.

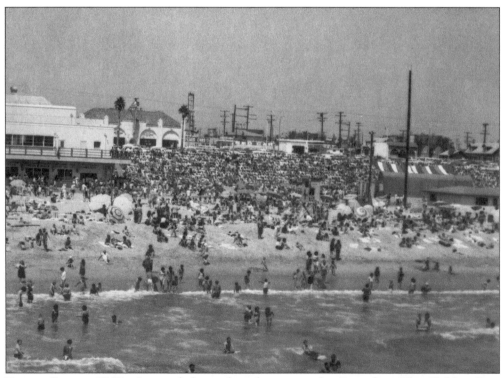

BEACH SCENE, 1940. A crowded grandstand next to the Pav-a-lon. The Golden Bear restaurant can be seen in the background.

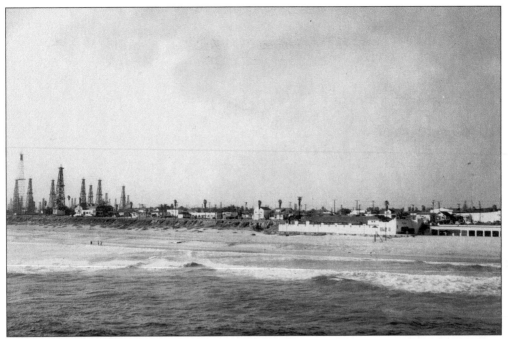

BEACH SCENE, 1940. Taken from near the tip of the pier, the Saltwater Plunge is seen on the right and oil derricks have sprouted up on the far left.

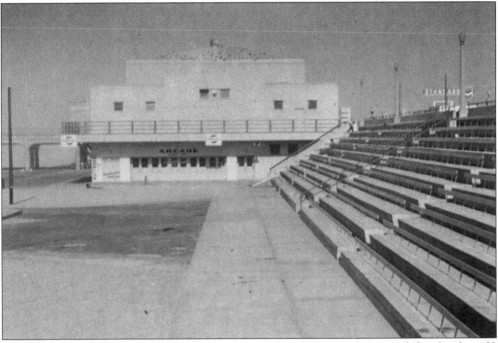

PAVILION AND BLEACHERS, 1940. City Historian Alicia Wentworth snapped this shot herself. This is the new Pavilion (called the "Pav-a-lon", straight ahead) and the new bleachers, built in 1939. This pier is visible on the left.

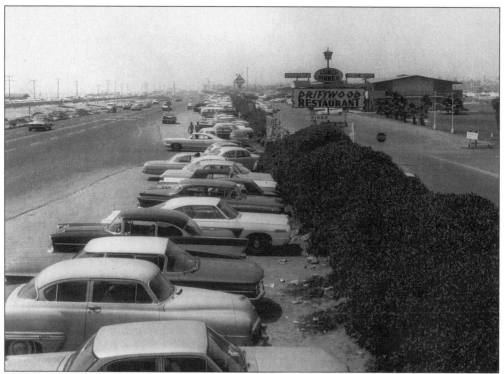

DRIFTWOOD RESTAURANT, 1960s. Many restaurants like the popular Driftwood used to dot Pacific Coast Highway. Today, most of them are gone. The site where this place once stood will soon be home to a luxury hotel complex.

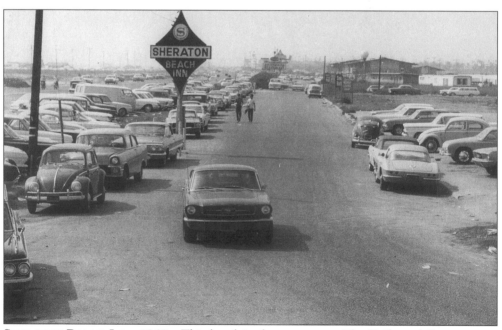

SHERATON BEACH INN, 1960s. This hotel is also now gone. The Driftwood Restaurant is visible further on down Pacific Coast Highway. The ocean is to the far left

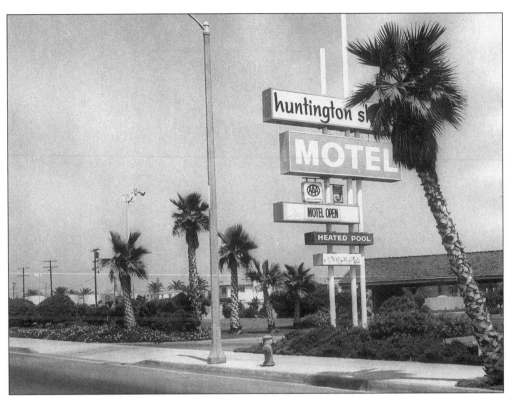

HUNTINGTON SHORES MOTEL, 1960s.

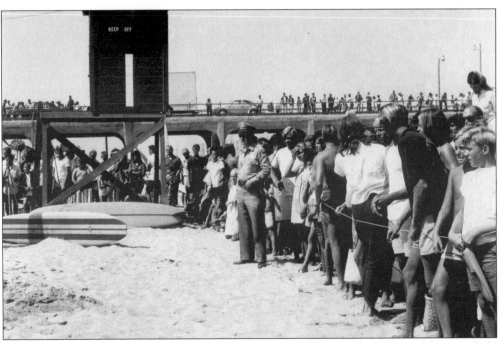

SURFING CHAMPIONSHIP BEACH CROWDS, 1963. When the Surfing Championships are held here each year, both the beach and pier above become Standing Room Only.

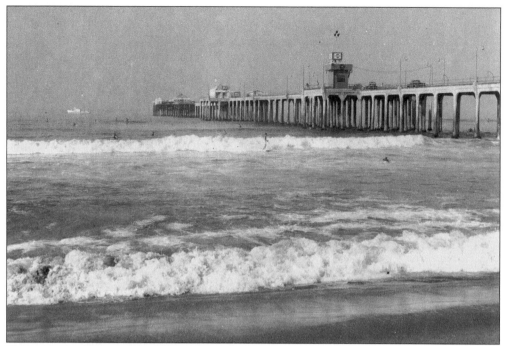

HUNTINGTON BEACH PIER, 1963. The surfers are out on this relatively quiet morning near the pier.

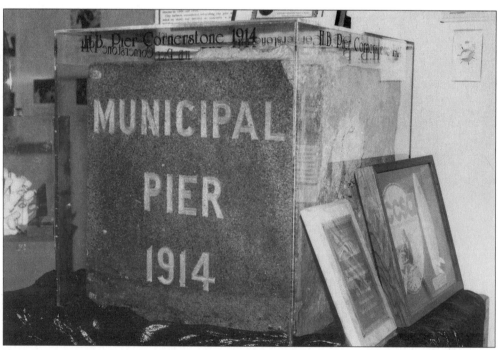

PIER CORNERSTONE, 1914. This piece of city history now sits in the International Surfing Museum, located at 422 Olive, just off Main Street. (Photo taken by author.)

Three

OIL!

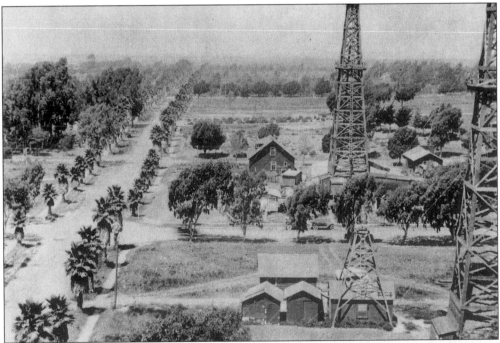

THIRTEENTH AND PALM, 1920. Thirteenth Street runs horizontally and Palm vertically in this interesting shot which typifies the first encroachment of the oil boom into this quiet, pastoral community. The face of Huntington Beach would never be the same again.

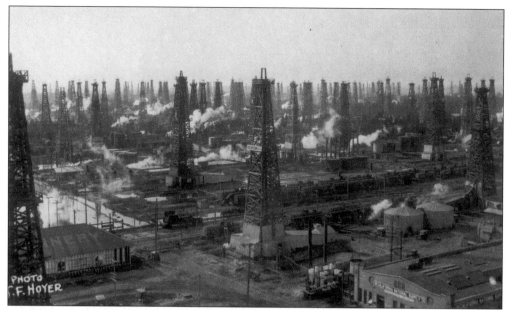

THE OIL BOOM IS UNDERWAY, 5/10/23. This photo, which appears to have been taken from atop one of the oil derricks, dramatically illustrates the physical changes that Huntington Beach experienced after oil was discovered.

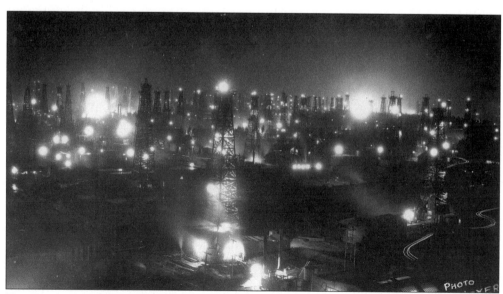

THE EXACT SAME SHOT AS ABOVE, AT NIGHT. On the evening of May 10, 1923, the city takes on a surreal glow from the illuminated oil towers.

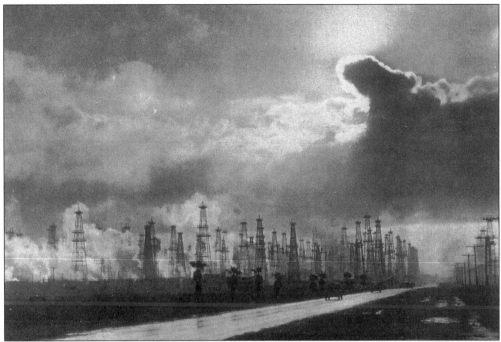

PACIFIC COAST HIGHWAY, 2/16/28. Oil derricks had become the most dominant facets of the Huntington Beach landscape by the late twenties, creating an almost futuristic-looking skyline, visible from virtually any vantage point in town.

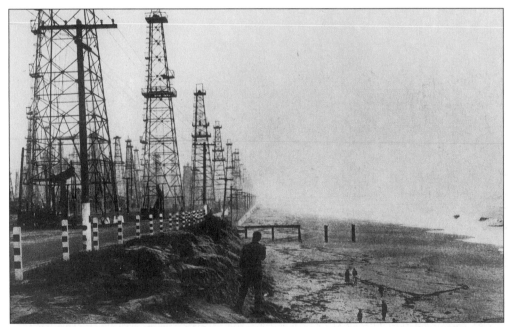

ALONG PACIFIC COAST HIGHWAY, MID-1920S LOOKING TOWARD THE PIER. This photo originally appeared in National Geographic in a feature on Huntington Beach. One wonders how the sound and smell of the nearby derricks affected the conversations of those couples seen strolling near the shore.

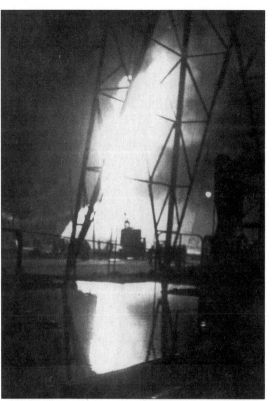

THE INFAMOUS PACIFIC COAST HIGHWAY FIRE OF 1949. What began as a peaceful summer morning became a 3 1/2 day nightmare when an oil well at Goldenwest Street and Coast Highway exploded and caught fire. Perhaps the most spectacular local disaster in city history, the out-of-control inferno was caught on film as it raged into the night by City Historian Alicia Wentworth.

MAYORAL PHOTO-OP, MID-1940S. Huntington Beach Mayor Tom Talbert is pictured on the right and City Engineer Harry Overmeyer on the left (man in center unidentified). The area seems to be getting cleared for more oil digging.

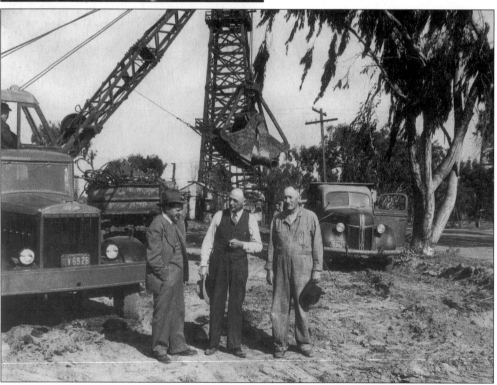

CHRISTMAS, 1939. Oil production was playing a big part in the development of Huntington Beach, as evidenced here by an oil derrick that's bedecked in festive holiday attire.

DOWNTOWN HUNTINGTON BEACH, 1950. At first glance, this could be a Hollywood premier, with cars arriving at the red carpet in front of the Klieg lights. But it's not. It's a city where oil has become the biggest star in town.

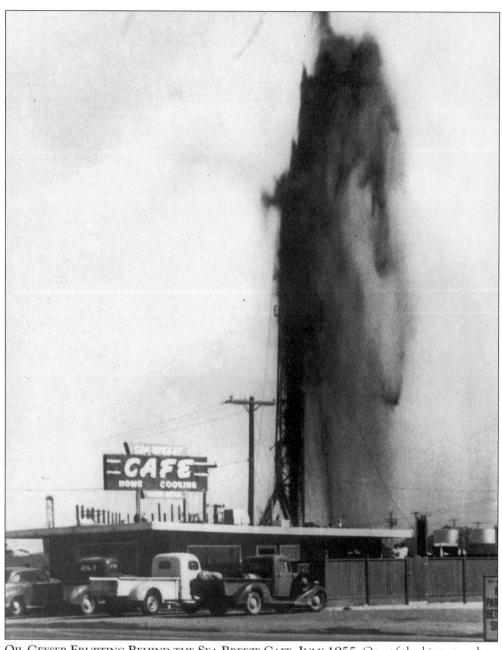

OIL GEYSER ERUPTING BEHIND THE SEA BREEZE CAFE, JULY 1955. One of the biggest gushers in city history is photographed from Pacific Coast Highway near First Street.

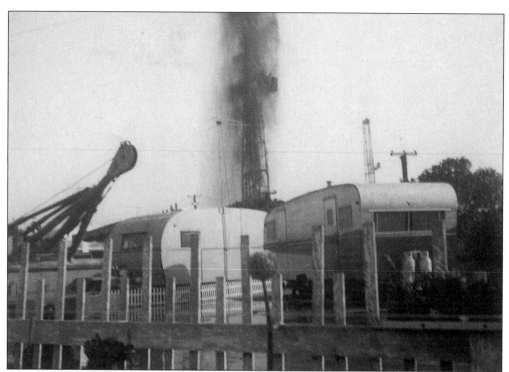

JULY 1955 OIL GEYSER, JULY, 1955. These candid amateur shots were all taken from various points in the nearby Municipal Trailer Park.

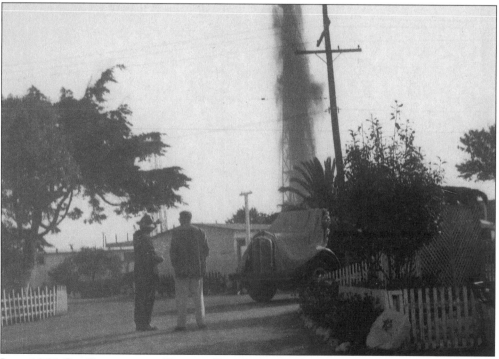

JULY 1955 OIL GEYSER FROM TRAILER PARK—ANGLE #2.

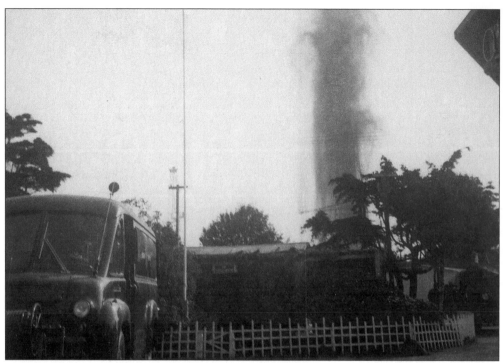

JULY 1955 OIL GEYSER FROM TRAILER PARK—ANGLE #3.

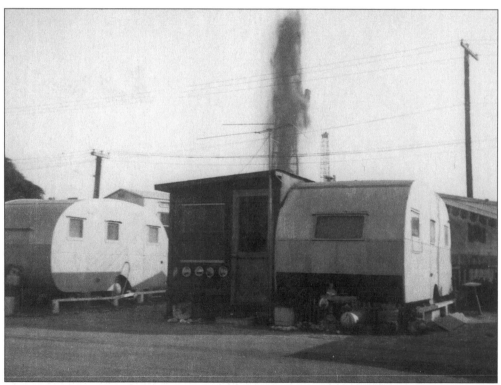

JULY 1955 OIL GEYSER FROM TRAILER PARK—ANGLE #4.

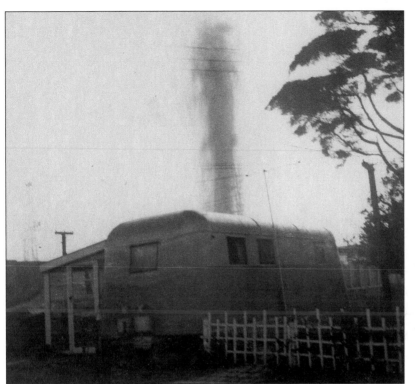

JULY, 1955
OIL GEYSER
FROM TRAILER
PARK—ANGLE
#5.

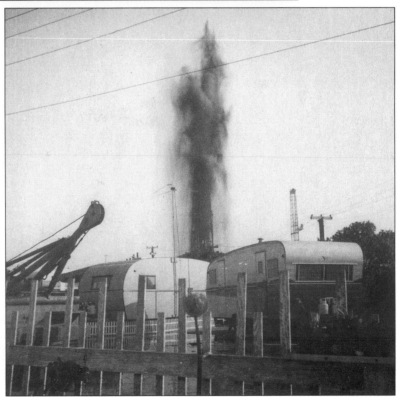

JULY, 1955 OIL
GEYSER FROM
TRAILER
PARK—ANGLE
#6.

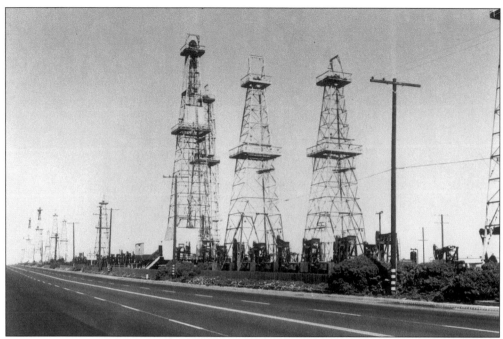

PACIFIC COAST HIGHWAY, 1970. This stretch of Coast Highway from 23rd Street to the bluff reveals how the towering derricks were becoming dinosaur-like, inching ever slowly toward extinction. While the towers have been removed, many of the wells are still active today.

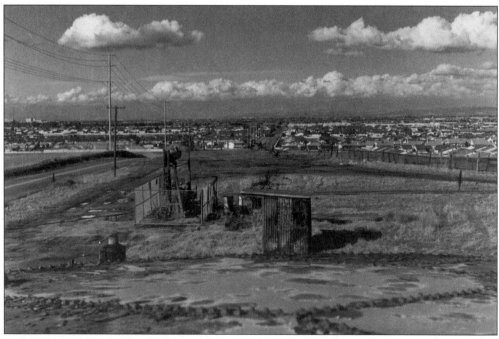

DISCOVERY #1. Located near the intersection of Clay and Goldenwest, this was the one that started it all—the very first oil well in Huntington Beach. (MORE TK)

Four
HOLIDAY PARADES

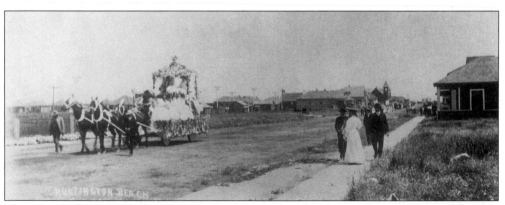

MAY 1, 1906, MAIN STREET. Parades have long played an important part in the culture of Huntington Beach. It started in 1904 with a 4th of July parade in honor of William Huntington, however, this happens to be a May Day parade, heading toward the ocean, on Main Street.

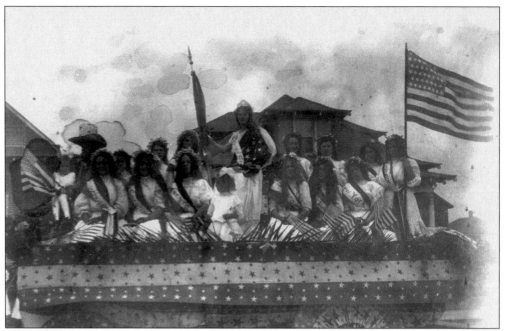

FOURTH OF JULY, 1908. The "Goddess of Liberty" float graced the 1908 parade, with each one of the girls representing one of the original 13 states.

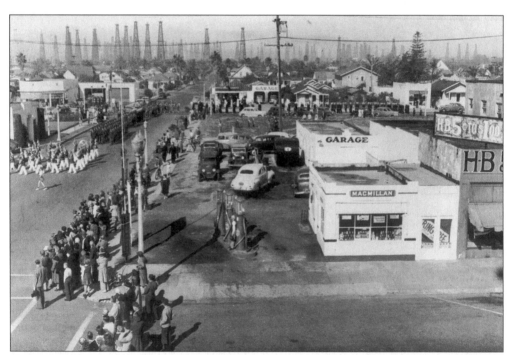

OLIVE AND MAIN, LATE-1930S. Another Huntington Beach 4th of July parade. Here, the oil wells create an almost false-looking backdrop. Note the sign atop the building to the right which reads, "HB 5¢ to $1.00 Store," and the building to the far left of the photo (with the bush columns). Today, this building houses the International Museum of Surfing.

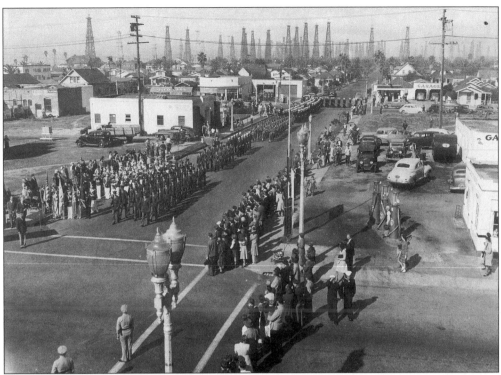

OLIVE AND MAIN, LATE-1930S. Another shot from the same parade; the building which now houses the International Surfing Museum is seen in the left-center of this photo.

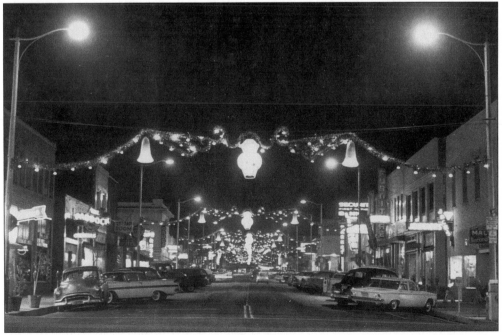

CHRISTMAS LIGHTS ON MAIN STREET, c.1960. The shot is taken from the head of the pier, looking away from the ocean and down Main Street.

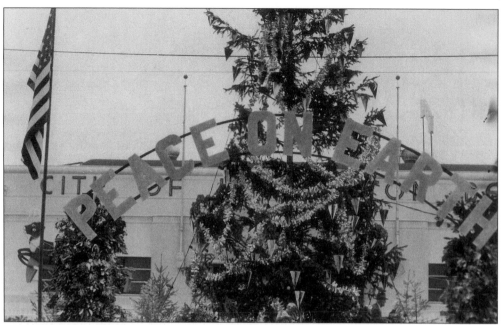

CITY CHRISTMAS TREE, C. 1940S, DAY. In addition to the holiday parades, for years the city put up a Christmas tree in front of the Pav-a-lon, today the site of Dukes Restaurant.

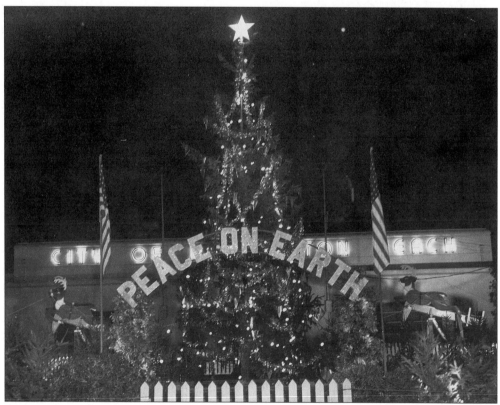

CITY CHRISTMAS TREE, C. 1940S, NIGHT.

FOURTH OF JULY PARADE, C. 1930. The Huntington Beach City Council (and a partially hidden little boy) marches in the annual 4th of July Parade. Pictured, left to right are: Tom Talbert, John Marion, Boxie Huston, Anthony Tovatt, Willis Warner, A.C. Marion (boy), Ray Overaker, and Lee Chamness.

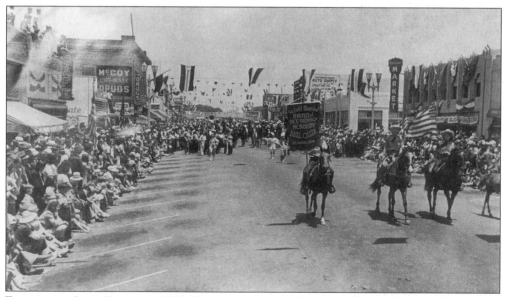

FOURTH OF JULY PARADE, 1935. Huge crowds cram the sidewalks along Main Street, near Walnut.

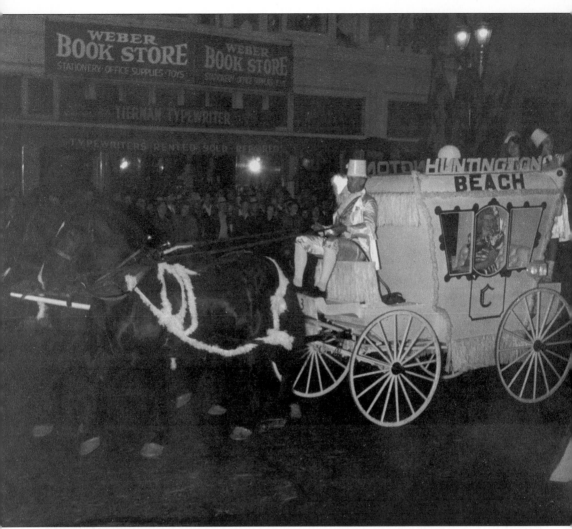

HUNTINGTON BEACH CHRISTMAS PARADE, C. 1940S. Here, a horse-drawn carriage passes the Weber Bookstore on Main Street.

Five
SURF CITY

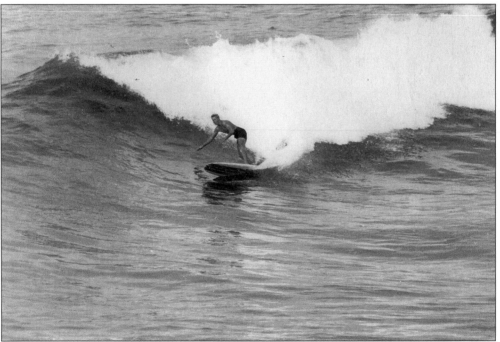

SURF CITY, U.S.A., 1963. Jan and Dean were to immortalize Huntington Beach in the song, "Surf City," and this shot beautifully captures the mood of the time.

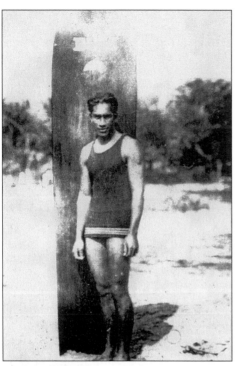

DUKE KAHANAMOKU. He's the most famous name in surfing—an Olympic champion, Hollywood actor, and Hawaiian folk hero. Duke Kahanamoku is the man credited with surfing to the mainland. This photo was taken by Ezra E. Nidever and was probably snapped in Hawaii, just a couple of years before Duke's first visit to Huntington Beach.

SPECTATING. The Duke watches the Surfing Championships just several months before his death.

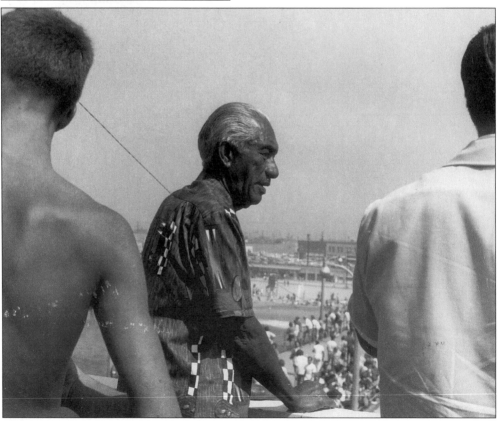

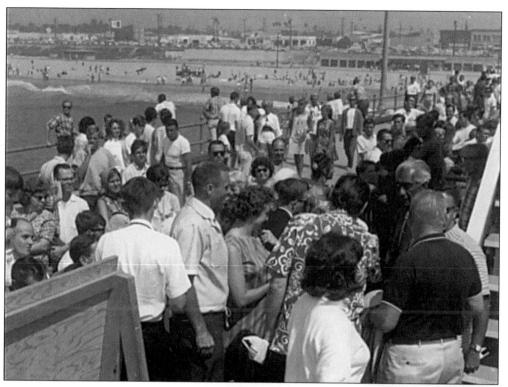

The Duke is Mobbed, 1963. Duke Kahanamoku, seen at right-center, is mobbed on the Huntington Beach pier by fans.

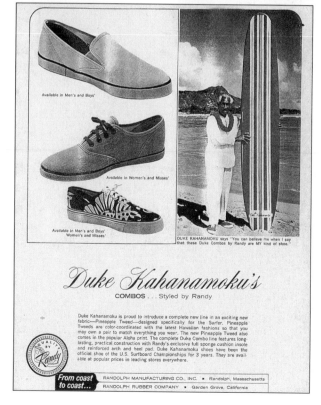

DUKE KAHANAMOKU says "You can believe me when I say that these Duke Combos by Randy are MY kind of shoe."

Available in Men's and Boys'

Available in Women's and Misses'

Available in Men's and Boys' Women's and Misses'

Duke Kahanamoku's
COMBOS . . . Styled by Randy

Duke Kahanamoku is proud to introduce a complete new line in an exciting new fabric—Pineapple Tweed—designed specifically for the Surfer. Pineapple Tweeds are color-coordinated with the latest Hawaiian fashions so that you may own a pair to match everything you wear. The new Pineapple Tweed also comes in the popular Aloha print. The complete Duke Combo line features long-lasting, practical construction with Randy's exclusive full sponge cushion insole and reinforced arch and heel pad. Duke Kahanamoku shoes have been the official shoe of the U.S. Surfboard Championships for 3 years. They are available at popular prices in leading stores everywhere.

From coast to coast... RANDOLPH MANUFACTURING CO., INC. ■ Randolph, Massachusetts
RANDOLPH RUBBER COMPANY ■ Garden Grove, California

Advertisement Featuring the Duke. Duke Kahanamoku was no stranger to endorsements, as evidenced by this ad for "Pineapple Tweed" fabric shoes.

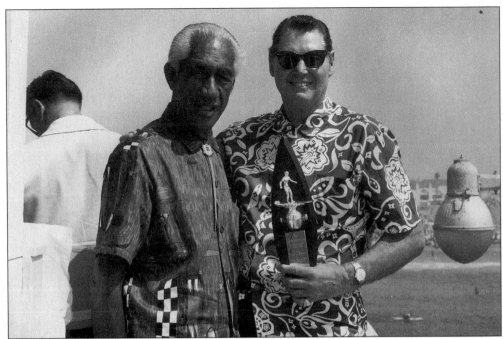

THE DUKE AND JOHNNY WEISMULLER, 1967. Two legends get together at the 1967 Surfing Championships. It was at the 1924 Paris Olympics that a 20-year-old Johnny Wiessmuller uncrowned the Duke.

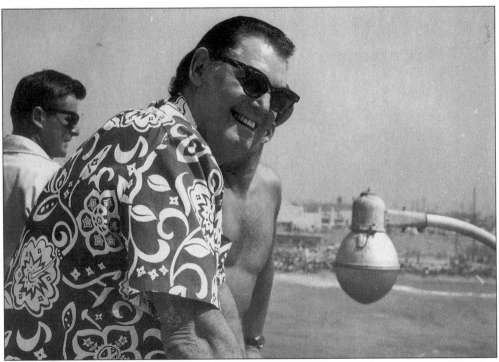

JOHNNY WEISMULLER ON THE PIER, 1967. The original "Tarzan" takes in the 1967 Surfing Championships.

MAYOR DON SHIPLEY, 1970.
The mayor is shown here
performing a Hula
demonstration during the 1970
Surfing Championships.

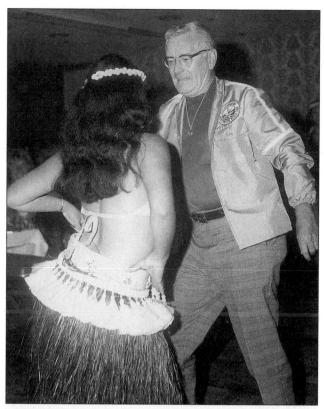

**SURFING CHAMPIONSHIPS,
CATCHING SOME RAYS.**
Seemingly oblivious to the
hordes of people on the pier
and in the water, these two
women in the center of the
picture have a more important
task at hand—getting a tan.

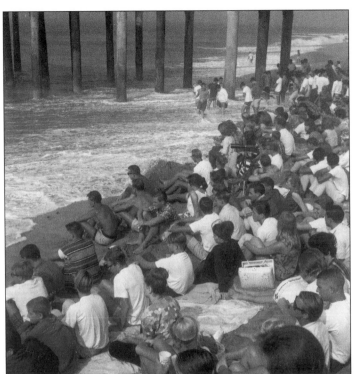

SURFING CHAMPIONSHIPS, FRONT-ROW SEATS. Fans watch the competition from the water's edge.

SURFING CHAMPIONSHIPS, BY THE PIER. A surfer relaxes against the pier, and dozens more huddle in the shade beneath as the sun beats down on the championships.

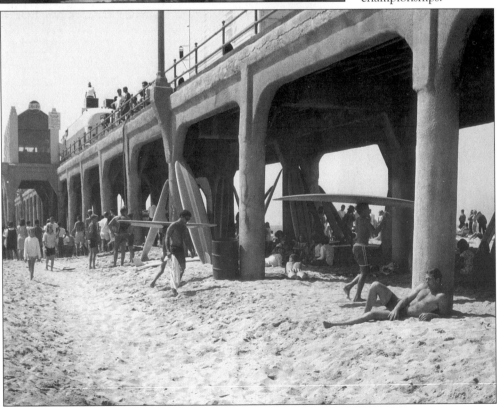

SURFING CHAMPIONSHIPS, BY THE SIDE OF THE PIER. A surf band plays near the trophy table as a bikini-clad fan enjoys the festivities.

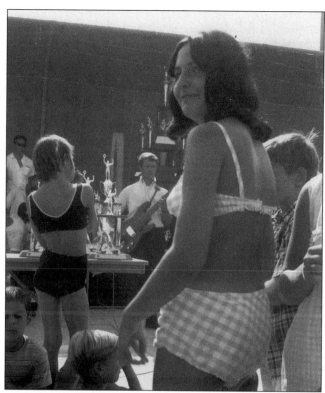

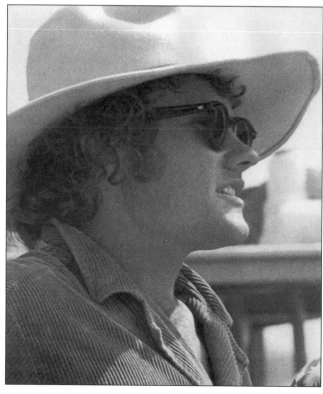

CORKY CARROL.

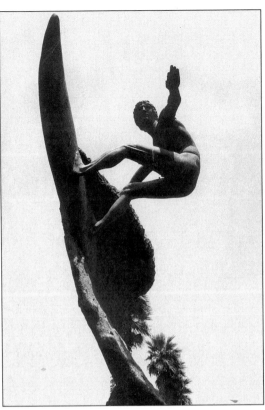

SURFER STATUE, 1997.

SPECTATORS WATCHING SURFING
CHAMPIONSHIPS FROM THE PIER, 1968.
It's hard to make out, but a headline on
the paper at the far right of the picture
near center is symbolic of the Summer of
Love. It reads, "Stoked on Jesus."

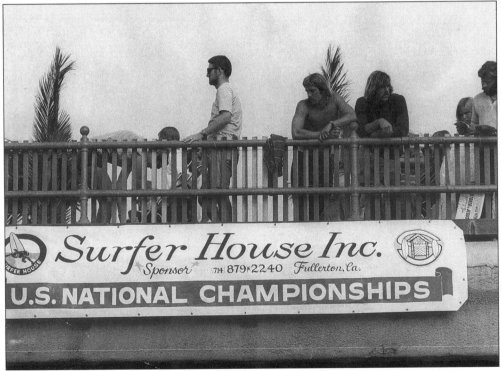

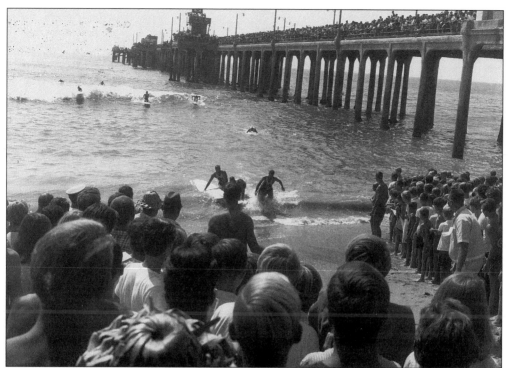

SURFING CHAMPIONSHIPS. The 1963 Surfing Championships in Huntington Beach were the first ones ever to be televised. A KHJ-TV banner is barely visible atop the lifeguard tower near the top of this photo.

FUTURE SURFERS, EARLY 1960S. They say that kids in Huntington Beach can surf before they can walk. Maybe it's something in the water.

SURFING CHAMPIONSHIPS.
An unidentified surfer
prepares to compete in the
1963 finals (wide).

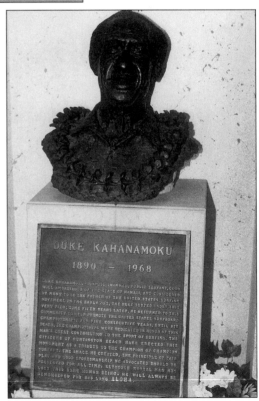

DUKE BRONZE BUST/PLAQUE, TODAY.
This was once located at the head of the
pier, but today you can find it inside the
International Museum of Surfing.

Six

FROM THE SKY

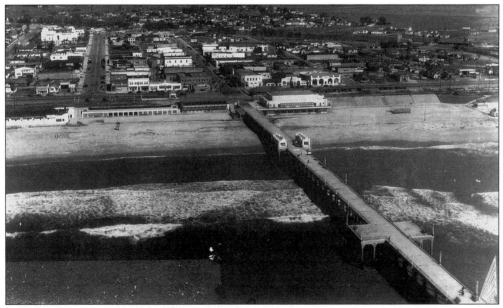

PIER AND CITY PANORAMA, 1939. This postcard view captures the city on a quiet day. Main Street runs into the pier, Fifth Street runs parallel to the left of Main. At the very top of the photo, oil wells can be seen in the far distance.

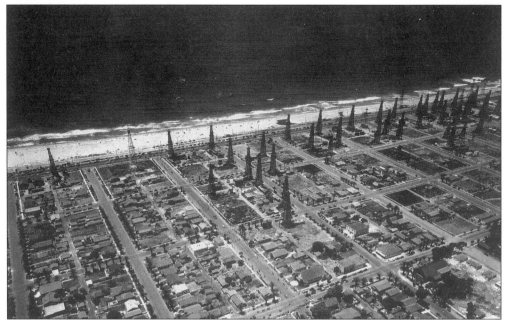

TENTH STREET HEADING WEST, C. 1940S. Tenth is the second street over from the left, and the derricks begin just to the right of Eleventh Street. This "forest" of oil wells helped define the face of the city for many years.

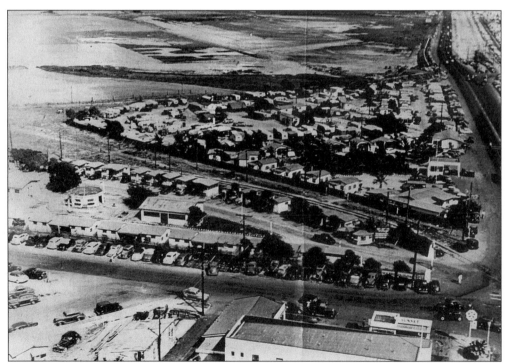

LAKE AND PCH, 1946. The Sea Breeze Auto Park is the large, triangle-shaped region near the center of the photo. Coast Highway is on the far right, and the train tracks of the Red Line can be seen cutting through the center of the photo, just below the trailer park.

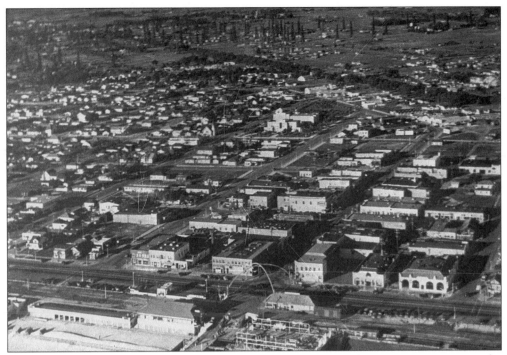

DOWNTOWN, 1938. In this lower center of this photo, the Pav-a-lon restaurant is seen under construction, directly adjacent to the pier. Directly above that, the arch at Main and Coast Highway is visible, along with dozens of oil derricks at the top of the photo (just east of the pier).

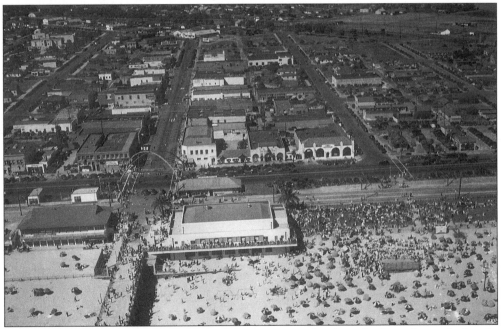

DOWNTOWN, SUMMER 1940. The Pav-a-lon is now completed on this busy day at the beach. Three buildings to the right of the arch is the famous Golden Bear Cafe, an entertainment landmark for about 60 years.

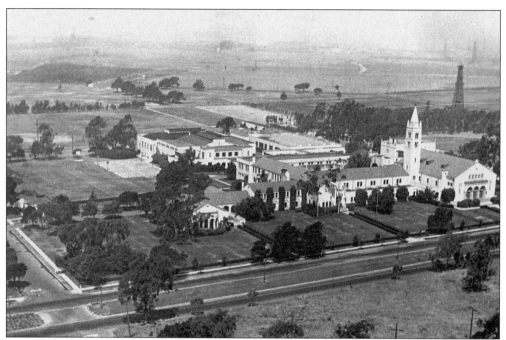

HUNTINGTON BEACH HIGH SCHOOL, 1946. All that remains of the high school, built in 1926, are the auditorium and clock tower at the far right of the picture. The rest of the buildings were town down in 1976, but the auditorium and tower have been designated as Orange County Historical Landmarks. Much of the open space beyond the school is now heavily residential.

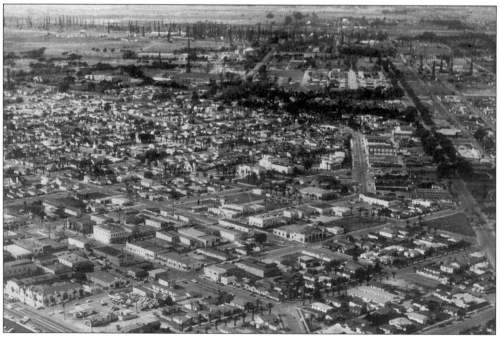

PACIFIC COAST HIGHWAY AND LAKE STREET, 1950. Note the dozens of oil derricks in the north part of town, at the top of the photo.

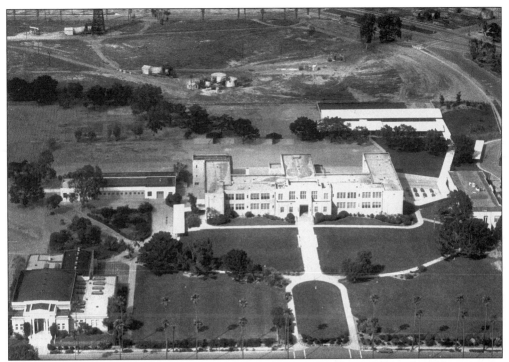

PALM AND FOURTEENTH STREET, 1950. Palm Street runs right to left at the bottom of the photo. The Dwyer Middle School is seen at the center of the photo, and the city gym and pool are on the left. The gym and pool building remain today after being recently restored.

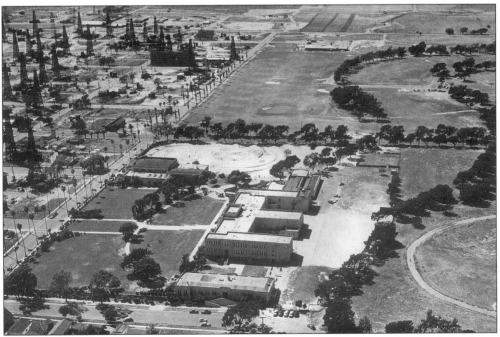

PALM AND FOURTEENTH STREET, C. 1940. This different angle of the previous photo shows the man oil derricks just to the south of Palm.

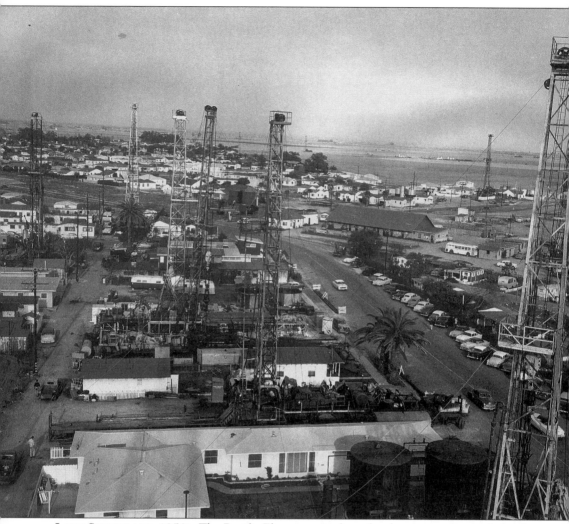

LAKE STREET, MID-1950S. The Pacific Electric train depot has been moved to its Lake Street location from Main Street (right center of photo). By this point, the oil wells on this stretch of PCH have become particularly invasive.

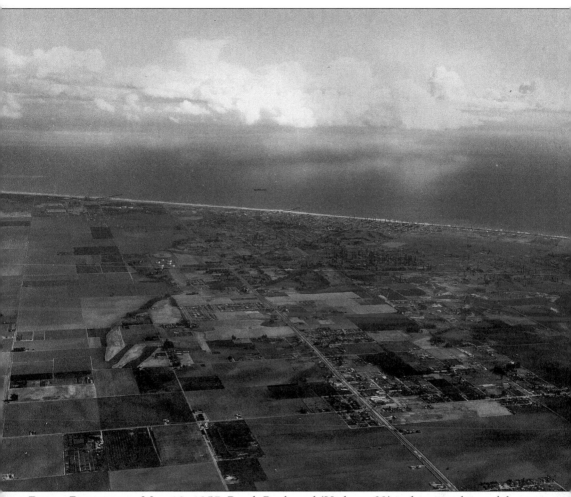

BEACH BOULEVARD, MAY 10, 1957. Beach Boulevard (Highway 39) is the main thoroughfare cutting through the center of this photo toward the ocean. In the very center of this photo the Huntington Beach pier can barely be made out. To the south (left) of Beach Boulevard remain the farmlands. To the north (right) the landscape is dotted with oil wells.

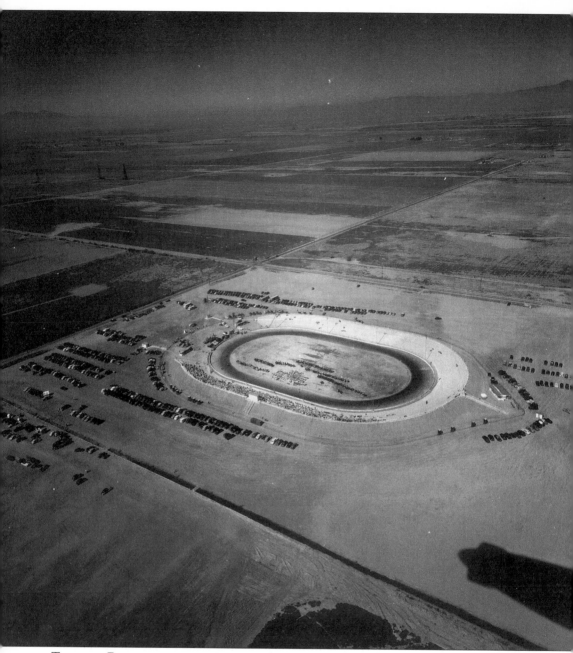

TALBERT RACETRACK, LATE-1940S. Also called the Huntington Beach Speedway, this popular track featured jalopy races, midget auto races, and more. Beach Boulevard cuts through the center of this shot above the track, and the shadow of the blimp holding the photographer is visible in the lower right corner.

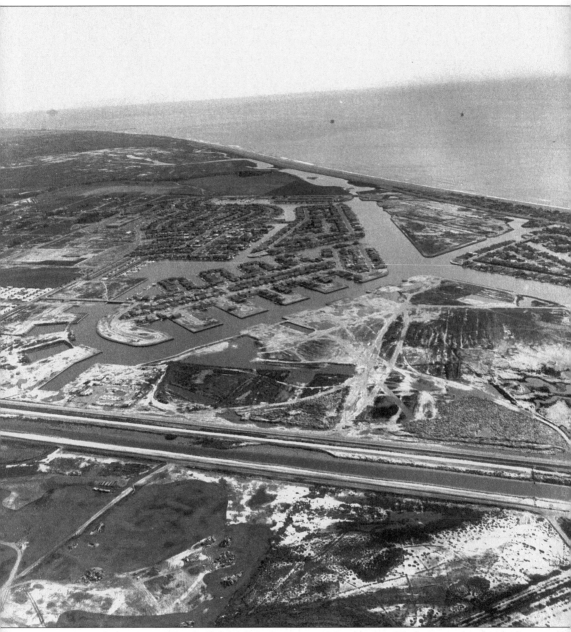

HUNTINGTON HARBOUR, UNDER DEVELOPMENT, 1974. Huntington Harbour is comprised of five islands. In this shot, Humboldt Island (where my family and I reside) is in the middle of the photo. Directly across from the bottom of Humboldt, Trinidad Island is being created. PCH is near the top of the page; Edinger is near the bottom.

PCH AND MAIN, 1980. The building to the left with the "HB" on its roof is Maxwell's, formerly the Pav-a-lon (later to become Dukes Restaurant, which is there today). The old Jack's Surfboards building is just above dead center, and the Golden Bear Cafe is at the far right, just up from center. Notice how the oil derricks no longer stand off the distance.

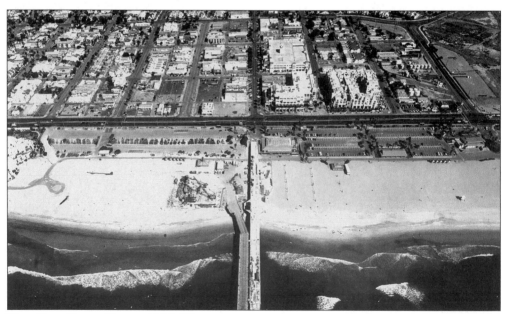

NEW PIER BEING BUILT, 1991. The construction staging area can be seen to the left of the pier on the beach as workers complete the pier that stands today. Downtown has undergone many radical changes by now, but the south east corner of PCH and Main (center of photo) is still barren—the new Jack's Surfboards building (that stands today) would soon be built.

Seven

DOWNTOWN AND PIER AREA

THEN AND NOW

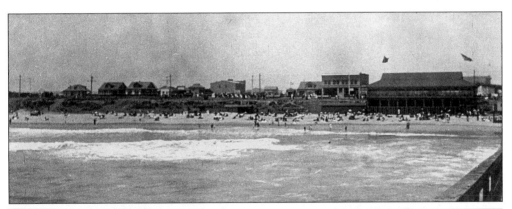

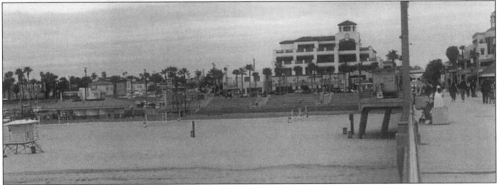

LOOKING BACK TOWARD THE SHORE OFF THE PIER, 1910 AND TODAY. Off the original wooden pier, the Pier Restaurant is seen just to the right of center. Several turn-of-the-century beach houses dot the bluff. Today, the large building at the right of center is where Jack's Surfboards is located. (Recent photo by author.)

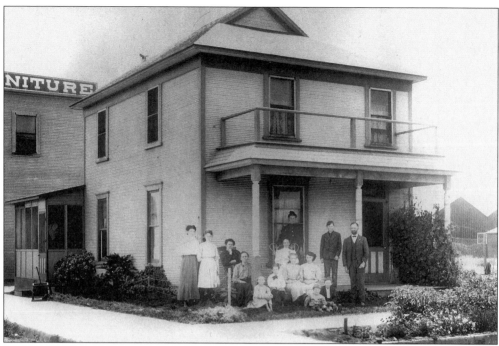

HELM HOUSE, 1916 AND TODAY. Matthew Helme's family poses here on the porch of the house they had moved by a mule team from Fifth and Verano Streets (11-miles away) to the corner of Sixth and Walnut in 1903. Today, the Helme House is still in the family, and was recently declared an historic landmark, protecting it at least for now. Mr. Helme was very influential, becoming the town's fourth mayor in 1916 and 1917 and spearheading the implementation of Huntington Beach's first gas lighting system and first water system. That's my son, Charlie, in the recent picture. (Recent photo by author.)

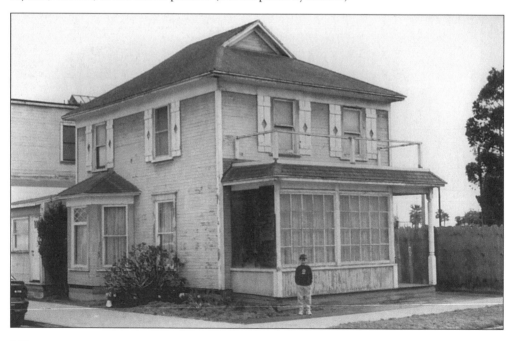

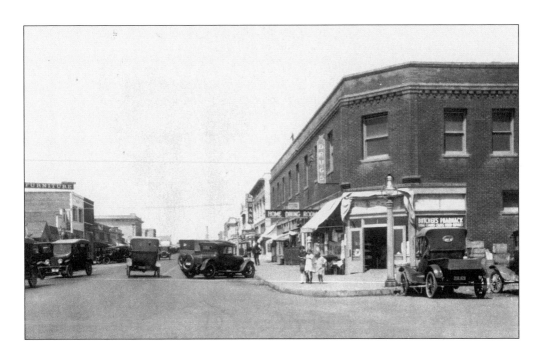

SOUTHEAST CORNER OF MAIN STREET AND OCEAN (PACIFIC COAST HIGHWAY), C. 1920 AND TODAY. The drugstore on the right corner has been replaced by a Mediterranean-style shopping plaza, and palm trees have been planted along Main Street. The old building with the furniture sign on top of it to the left can still be seen in the recent picture. (Recent photo by author.)

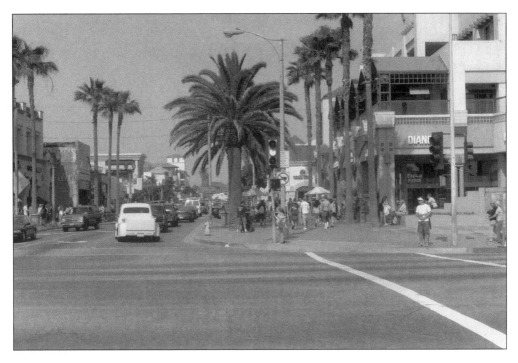

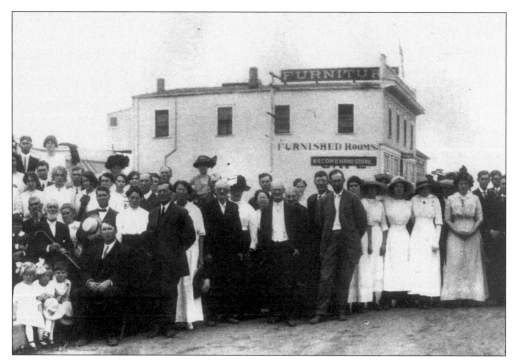

HELM FURNITURE COMPANY, ABOUT 1910 AND TODAY. The old photo shows family and friends of Matthew Helme (seen on the far left with the white beard) gathered in front of the Helme House Furnishing Company on Walnut Avenue. Little has changed on the building today, which, according to a sign in the window, is used by a local church. (Recent photo by author.)

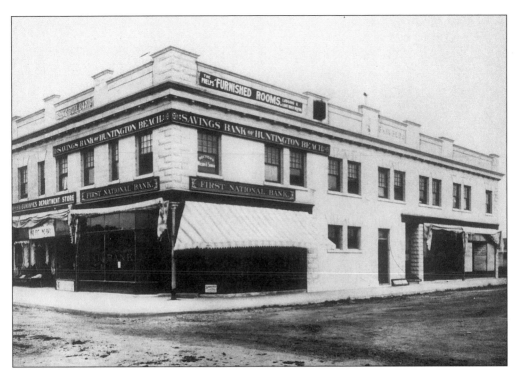

FIRST NATIONAL BANK, C. 1910, AND TODAY. Located on the corner of Main and Walnut Streets, the First National Bank Building was built in 1905. The storefront at the rear right corner was where the first city hall was located in 1909. Today, a popular restaurant sits on the site. (Recent photo by author.)

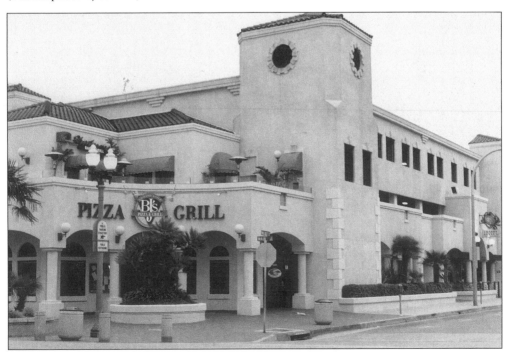

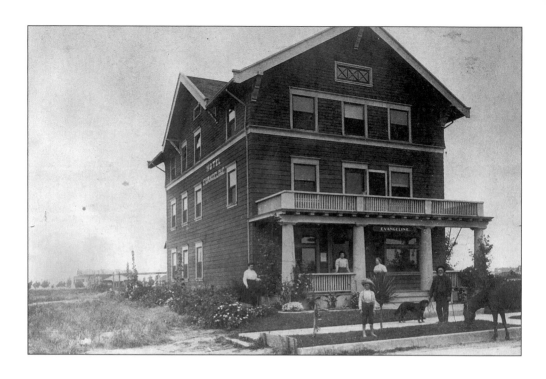

EVANGELINE HOTEL, 1906 AND TODAY. At one time it was the Evangeline Hotel, one of Huntington Beach's finest. Built in 1906, the Evangeline Hotel was a fine example of the Craftsman bungalow style. Today, the building serves a youth hostel. (Recent photo by author.)

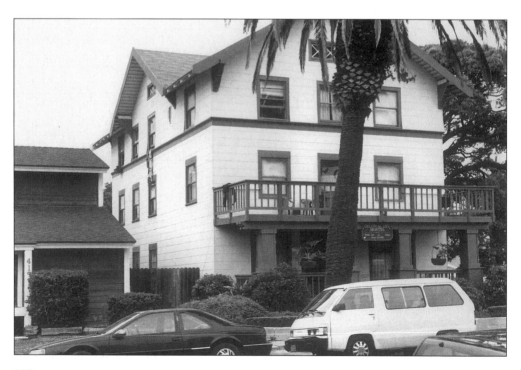

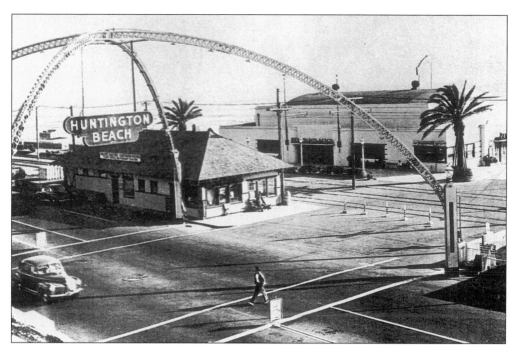

MAIN STREET AND PACIFIC COAST HIGHWAY IN THE 1930S AND TODAY. Once a bustling intersection, always a bustling intersection. In the old photo, you can see the arch, (which held the Huntington Beach sign), the Pacific Electric train depot in the middle, and the Pav-a-lon at the head of the pier. Today, the depot is gone and Dukes Restaurant, with the restaurant Chimayo located beneath it, sits where the Pav-a-lon used to be. Thanks to the gentleman who let me out onto the third-story balcony so I could climb up on a pedestal-ledge and get this shot.

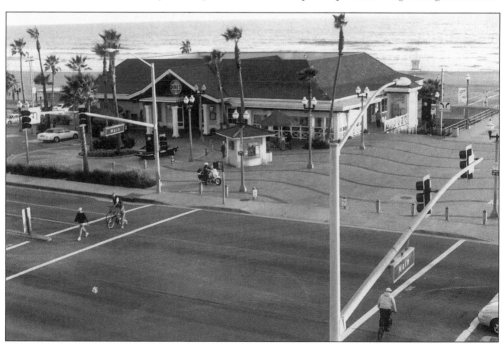

113

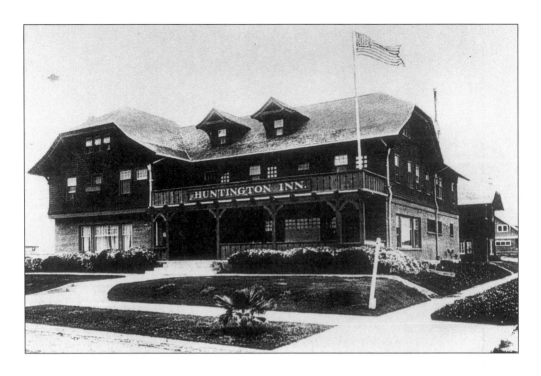

HUNTINGTON INN IN 1920 AND THE SAME SITE, TODAY. The Huntington Inn was located at Eighth Street and Pacific Coast Highway. For many years it housed the men who came to work in the oil fields. Later, the Elks Club used the facility as a meeting place. Knocked down in 1969, a Quality Inn now exists at the site. (Recent photo by author.)

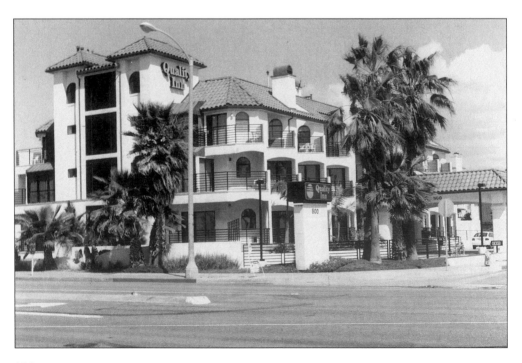

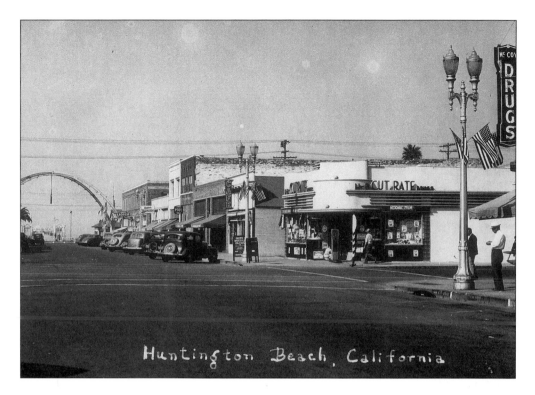

Huntington Beach, California

MAIN STREET AT WALNUT, 1938 AND TODAY. Just a block from the ocean, the head of the pier is visible at far left under the Main Street Arch. Today, the Mr. Cut Rate Drug store on the right is a souvenir shop. (Recent photo by author.)

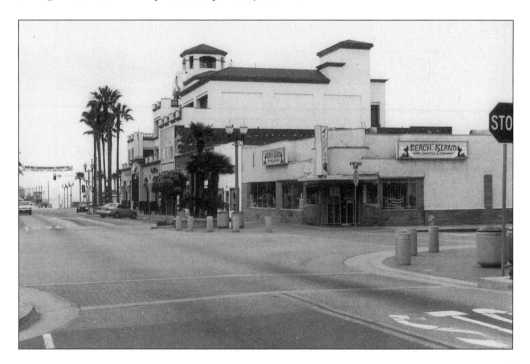

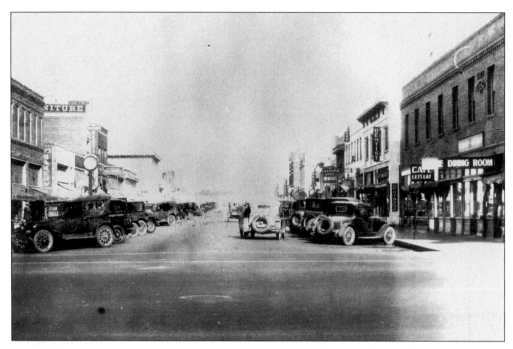

MAIN STREET AND PACIFIC COAST HIGHWAY, EARLY-1920S AND 1933. In the years between these two photos, the Main Street Arch has been built and a traffic light has been added. The cars at the right of the 1933 photo are taxis waiting for passengers next to the Pacific Electric train depot.

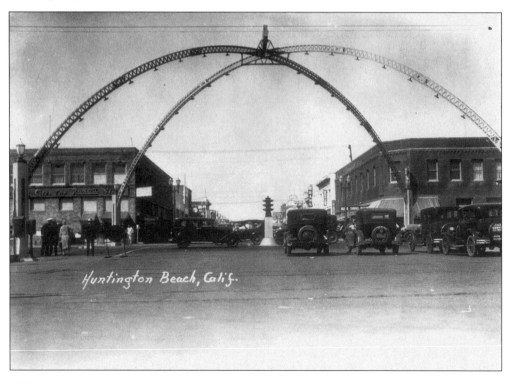

Huntington Beach, Calif.

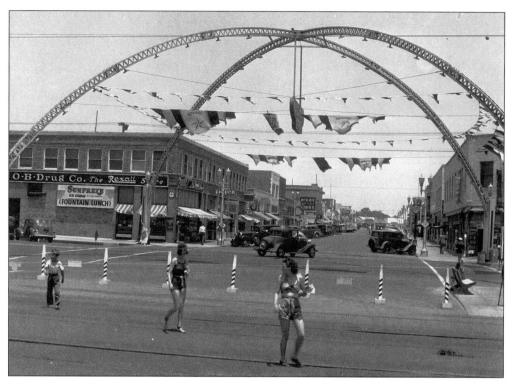

MAIN STREET AND PACIFIC COAST HIGHWAY, 1939 AND TODAY. The arch still has a year or so left before being taken down. The Rexall Drug Store is on the left. Today, the only building that remains is the former furniture store to the left of center in the most recent photo.

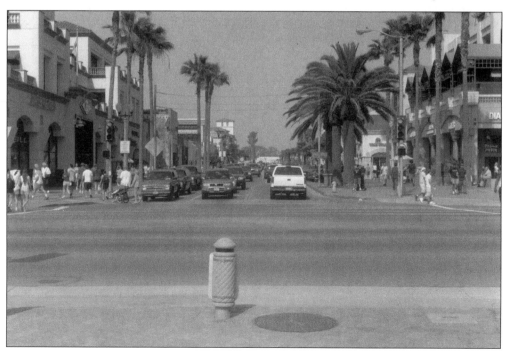

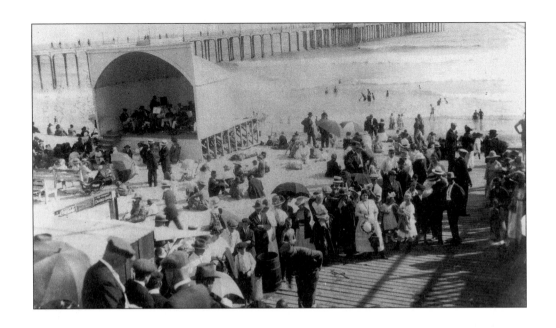

BANDSTAND AND PIER, 1920s AND TODAY. A band shell adjacent to the new concrete pier once featured popular performers and bands, which attracted even bigger crowds to the pier area. Today, the band shell is gone, but the pier remains. My son Charlie is sitting in the spot near where the shell once rested. (Recent photo by author.)

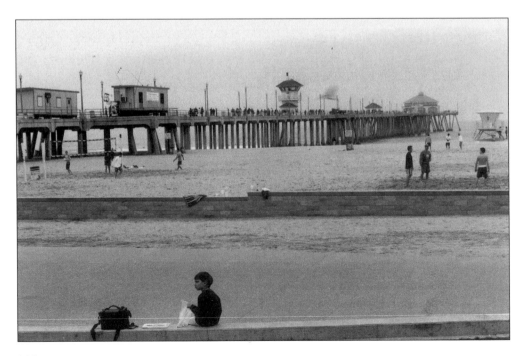

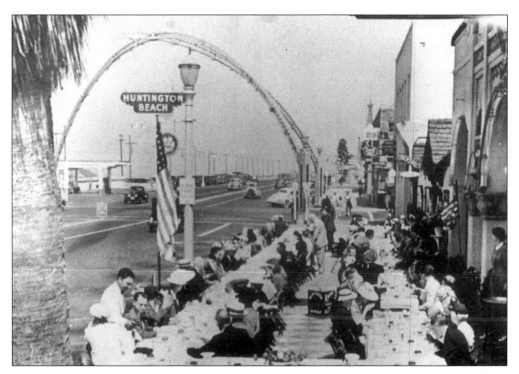

LUNCHEON OUTSIDE AT THE GOLDEN BEAR CAFÉ IN 1935, AND THE SAME SITE TODAY. The Golden Bear on Pacific Coast Highway began as an elegant restaurant patronized by many Hollywood stars in the 1930s. In the 1935 shot, you see a chamber of commerce luncheon in front of the Golden Bear. The arch can be seen, as well as the train depot to the far left and an oil derrick peeking in at the upper right. Today, the Golden Bear is gone; so are the arch, train depot, and oil derrick. (Recent photo by author.)

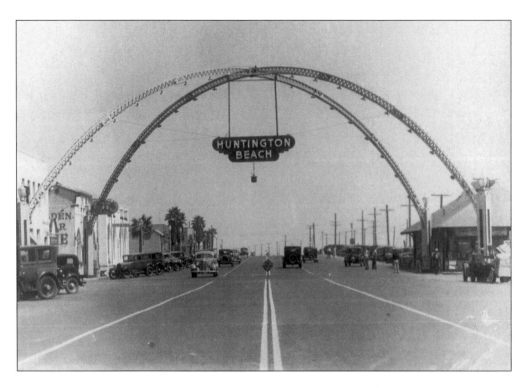

PACIFIC COAST HIGHWAY LOOKING SOUTH, 1935 AND TODAY. The Golden Bear Café is at the far left, and the train depot at far right of the 1935 photo. Today, the arms of the traffic lights extend out over where the arch used to be. (Recent photo by author.)

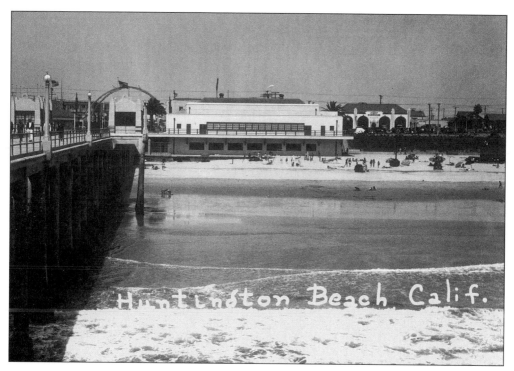

Huntington Beach Calif.

FROM THE PIER, LOOKING BACK TOWARD MAIN STREET, 1930S AND TODAY. In the old shot, you can see the arch at the far left and straight ahead, the Pav-a-lon. Today, straight ahead is the oceanfront side of Dukes Restaurant, with many new condos on the far right. (Recent photo by author.)

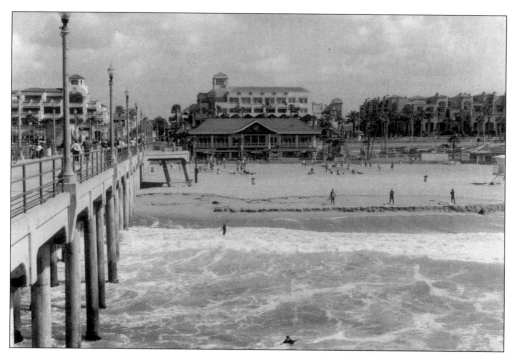

LOOKING WEST ALONG THE TRACKS TOWARD MAIN STREET, 1908 AND TODAY. The original wooden pier is off to the left, the Pier Restaurant near the center and the train depot is right of center in the older shot. Today, Dukes Restaurant is in the center of the shot, and the concrete pier sits off to the left. (Recent photo by author.)

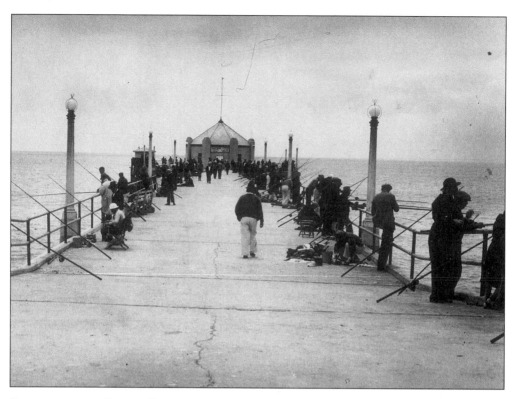

RESTAURANT AT END OF PIER, 1930S AND TODAY. The sign on the older place says "Anchor and eat." Today, Ruby's Restaurant sits at the end of the pier. Coincidentally, Ruby's design is similar to the place that sat there 70 years earlier. (Recent photo by author.)

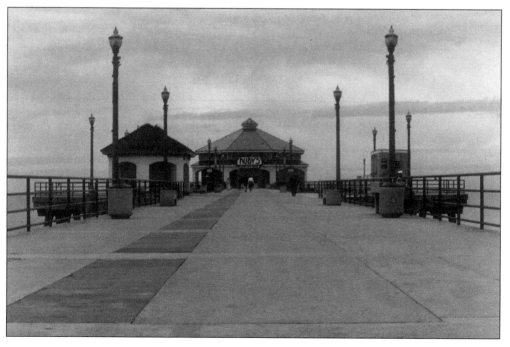

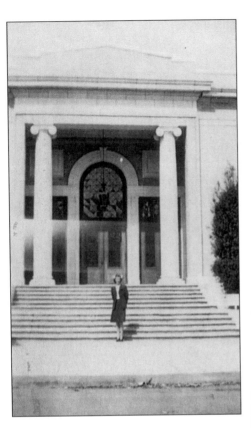

CITY GYM AND POOL, 1943 AND TODAY. The woman striking a pose is Betty Funkhauser, school district assistant superintendent. Today, the building has undergone a good deal of restoration and is still used as the city gym and pool. (Recent photo by author.)

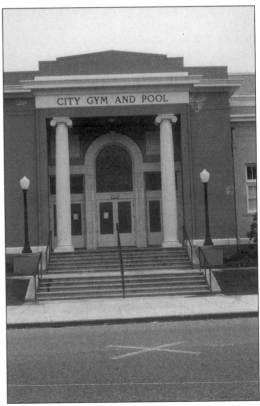

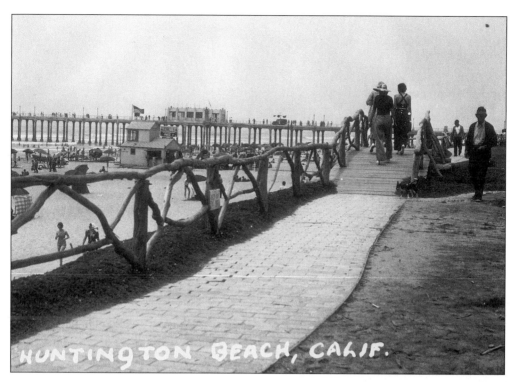

HUNTINGTON BEACH, CALIF.

SIDE VIEW OF THE PIER, C. 1930S AND TODAY. An elevated strand with a hand-carved wood railing once ran above the bluff leading over to the pier. Today, the area has been re-graded, so achieving the appropriate angle required shooting from the stairs leading up to the parking lot. (Recent photo by author.)

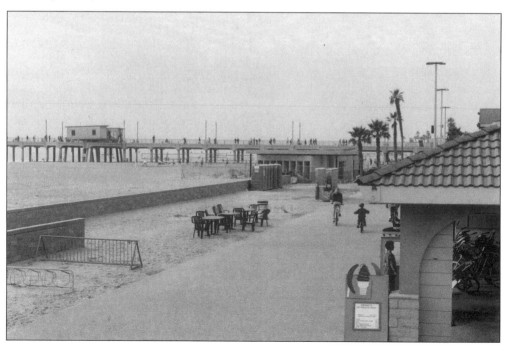

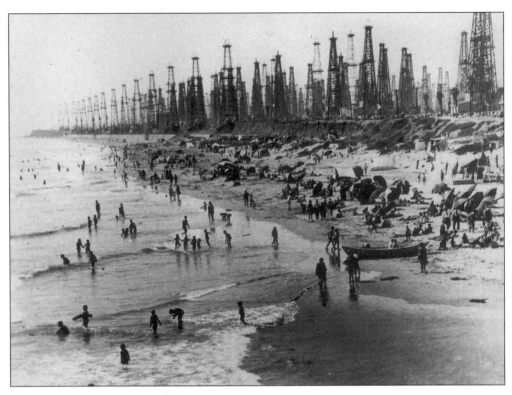

LOOKING OFF THE PIER, C. 1930S AND TODAY. Oil derricks at one time created a dramatic backdrop against the surf. They comprise the "Townlot Field," which was the second oil boom that occurred in 1926. Today, palm trees provide the backdrop. (Recent photo by author.)

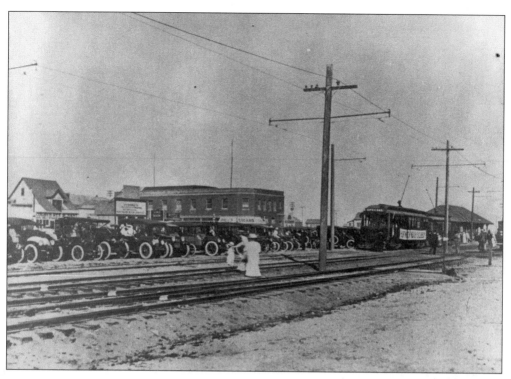

LOOKING EAST TOWARD THE DEPOT, 1910 AND TODAY. The ATM kiosk in the recent photo sits near the spot where the Pacific Electric Red Car sits in the old photo. In the center of the old photo is Vincent's Corner Confectionery, replaced today by a shopping center. (Recent photo by author.)

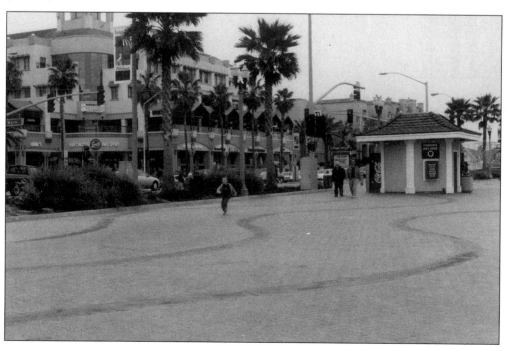

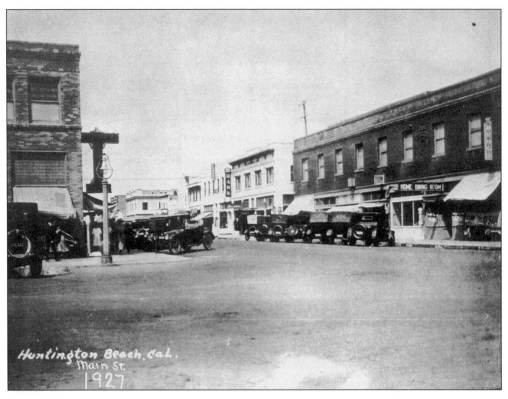

CORNER OF MAIN AND OCEAN, 1927 AND TODAY. These photos were taken across from the pier. The substantial two-story brick buildings have been replaced by lots of terra cotta. (Recent photo by author.)

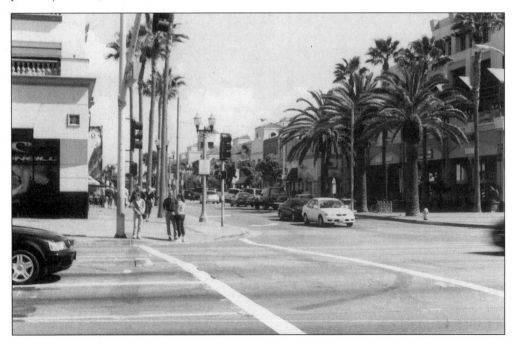